PLUTO *and*
LOWELL OBSERVATORY

PLUTO *and* LOWELL OBSERVATORY

A History of Discovery at Flagstaff

KEVIN SCHINDLER AND WILL GRUNDY

Contributions by Annette & Alden Tombaugh, W. Lowell Putnam and S. Alan Stern

THE
History
PRESS

.

Published by The History Press
Charleston, SC
www.historypress.net

Copyright © 2018 by Kevin Schindler and Will Grundy
All rights reserved

First published 2018

Manufactured in the United States

ISBN 9781625859792

Library of Congress Control Number: 2017960106

CONTENTS

FOREWORD

My brother and I exist because of Pluto. We are because of an icy dwarf planet with an average distance of 3.67 billion miles (5.89 billion kilometers) from planet Earth, where I was born ten years after my father discovered Pluto in 1930 at Lowell Observatory near Flagstaff, Arizona. I am Annette Tombaugh, the elder child of the discoverer of Pluto, Clyde W. Tombaugh. Pluto determined much of my life.

This book is the story of Pluto. The search for Pluto begins with math and continues with amazement. For sixty-seven years of my life, Pluto was nothing more than a speck of light on photographic plates. Then in 2007, at Lowell Observatory, Marc Buie showed me his compiled image of Pluto. The image was of a fuzzy world marked by oval-looking dark and light zones. As the New Horizons spacecraft approached Pluto in 2014–15, Pluto became a more defined world. I will never forget the Monday night of July 11, 2015. I was packing for my trip to Maryland for the New Horizons flyby. My husband, Wilbur Sitze, called me into our office and pointed at his computer. There was our Pluto in color with a big pinkish heart on it. "How beautiful! How appropriately perfect!" I exclaimed in awe. A large globe of Pluto's closely, clearly defined topography now dominates my living room much as that tiny speck of light dominated my life.

How could Alden and I exist because of Pluto? Because of our dad's discovery of Pluto, he received a college scholarship to the University of Kansas (KU). There he met another astronomy student named James

Edson. Clyde told James that he was looking for housing off campus. James's mom ran a boardinghouse, into which Clyde then moved. James had a younger sister named Patricia. Clyde and Patricia married in 1934. How appropriate the heart, Tombaugh Regio, is on Pluto!

My first home for two years was the Little House located just northeast of Lowell Observatory's Administration Building. In 1942, we moved down the hill to a house on West Aspen Avenue (now located on North Bonito Street, having been moved by its present owner several years ago) in Flagstaff. We moved to Las Cruces, New Mexico, in 1946. We returned to Flagstaff often. During the summer of 1952, we again lived in the Little House. That summer, I spent happy hours alone looking at spectra from objects in the universe and reading science and social studies books in Lowell's library located in the Administration Building's Rotunda. Lowell Observatory and Flagstaff will always feel like home to me.

I have known one of this book's coauthors, Kevin Schindler, for almost a decade. We first met in 2008 on one of my visits to Lowell Observatory. Mr. Schindler currently holds the title of historian at Lowell Observatory. I first met coauthor Will Grundy at New Horizons Mission events. Dr. Grundy is an astronomer at Lowell Observatory and was the leader of the surface composition science theme team for New Horizons. His specialty is the physical characterization and compositional studies of icy outer solar system bodies. His studies of ices include the use of ice labs at Northern Arizona University.

You will enjoy Kevin and Will's gripping accounts of Pluto—from early searches for it to scientists' modern understanding of its icy and varied topography.

Annette R. Tombaugh
Daughter of Clyde Tombaugh

This is a story of adventure told by the keepers of the history of an icy world of mystery known as Pluto, my ninth planet. The authors have lived in the modern era of the discovery about our solar system with the use of tools developed more than one hundred years ago and the marvel of ever-changing technology. Kevin Schindler and Dr. William Grundy give readers insight to the developments of Percival Lowell's ninth planet theories; the discovery of Pluto by my father; the tedious subsequent searches by Lowell Observatory and planetary scientists around the world;

the flight of the New Horizons spacecraft; and the knowledge gained through these endeavors.

Pluto defined our family. Our daily life was influenced by my father's discovery through the pride of accomplishment and the burden of fame. Although the "demotion" of Pluto troubled our family, the recent revelations about that speck of light my father saw on the photographic plates have renewed our pride. We are thankful for the expertise and literary proficiency of Kevin and Will in bringing these writings to all those stimulated by the discoveries of mankind.

<div align="right">

Alden C. Tombaugh
Son of Clyde Tombaugh

</div>

PREFACE

For all great works imagination is vital; just as necessary in science and business as it is in the novels and art....Imagination harnessed to reason is the force that pulls an idea through. Reason, too, of the most complete, uncompromising kind. Imagination supplies the motive power, reason the guiding rein.
—*Percival Lowell*

In the late summer of 2006, scores of visitors who flock to Lowell Observatory each year voiced their disdain at the news of Pluto being "demoted," "kicked out of the solar system" and getting called "ugly names like dwarf planet." One guest asked a tour guide, "Are you guys at Lowell going to be okay, now that they have taken your planet away?" with emphasis on the word *they*, implying some nefarious, evil-plotting, mysterious entity.

Such was (and still is) the reaction from much of the public about Pluto's reclassification. Many people have been inspired to visit Lowell Observatory in Flagstaff, Arizona—Pluto holy land, as it were—to offer their condolences and support. They and others want, in fact often thirst for, more information about this much-discussed, enigmatic world and its family of satellites.

Lowell Observatory was certainly the right place for these pilgrims to go, because not only did human awareness of Pluto start here with its detection by Clyde Tombaugh in 1930, but virtually every other major discovery related to Pluto has ties to Lowell or the surrounding Flagstaff community.

This includes Jim Christy's discovery of Pluto's largest moon, Charon, from images taken at the United States Naval Observatory's Flagstaff Station, located just a few miles west of Lowell, as well as the detection of other moons by teams of astronomers including Lowell's Marc Buie. Another Flagstaff tie involves the first definitive detection of an atmosphere around Pluto by observers from Lowell and elsewhere; the first surface maps, by Buie and colleagues; and the crème de la crème: the 2015 New Horizons mission's flyby of Pluto that included one of this volume's authors—Will Grundy—as the surface composition team leader.

Furthermore, one of the cornerstones of Lowell's mission is to share the mysteries of the universe around us, from the far reaches of distant galaxies to the celestially nearby neighbors in our solar system. The combination of these factors directly led to this book, a non-technical treatment of this icy little world. And who better to tell this story than the people who walk the hallowed halls of Lowell today, living and breathing all things Pluto. To underscore the Pluto/Lowell heritage, and to connect the old of Percival Lowell and Clyde Tombaugh with the new of New Horizons, we are pleased and grateful that the following individuals also contributed to this project: Clyde Tombaugh's children, Annette and Alden; Percival Lowell's great-grandnephew (and current sole trustee of Lowell Observatory) W. Lowell Putnam; New Horizons boss and virtual member of the Lowell Observatory family Alan Stern (who donated his car to the observatory for an auction supporting the 2017 renovation of the Pluto discovery telescope and dome); current Lowell director Jeff Hall; and current Lowell astronomer Gerard van Belle.

The pursuit of scientific knowledge and understanding is the thread that holds this story together, yet the Pluto-Lowell connection is much more than a tedious collection of scientific facts and discoveries. Other themes inevitably come to the forefront, including the idea of community pride and identity. Lowell Observatory and, by direct and active association, Flagstaff are considered the home of Pluto by the residents of northern Arizona. This has manifested itself in commercial efforts, such as a "Pluto Roll" at a local sushi restaurant; artwork by sculptors and painters who incorporate motifs of Pluto into their creations; and outright bragging by residents young and old.

Another theme that emerges is the concept of imagination, starting with observatory founder Percival Lowell himself, who frequently contemplated the importance of imagination in scientific pursuits. To him, collecting data was one thing, but the ability to interpret that data and formulate compelling

conclusions required an imaginative outlook. He wrote in his 1906 book *Mars and Its Canals*, "Imagination is as vital to any advance in science as precision and learning are as starting points." With this mindset, Lowell evaluated some anomalous astronomical observations of the time and devised a hypothesis introducing a theoretical ninth planet to explain the problem. He then led searches for his "Planet X" that culminated, fourteen years after his death, in the discovery of Pluto by Clyde Tombaugh.

Tombaugh himself incorporated a healthy dose of imagination into his life while growing up on farms in Illinois and, later, Kansas. During the long nights with not much else to do, he imagined himself an astronomer and took the steps to turn those musings into reality. Jim Christy certainly integrated imagination into his analysis of a slightly misshapen image of Pluto that had previously been interpreted as a poor-quality picture; he realized it actually revealed a moon orbiting Pluto. New Horizons scientists also put on their imagination caps not only in planning the mission but also in scrutinizing and explaining features shown on the incoming pictures. Outside of science circles, Pluto also captured the imagination of those artists and the public.

Finally, the story of Pluto in many ways mirrors the larger-scale story of Lowell Observatory itself. The observatory began on the fringes of mainstream science but matured into a place defined by serious and respected research. Likewise, Percival Lowell's search for a ninth planet started humbly and outside the purview of established scientific circles, but these early efforts ultimately led to Pluto's discovery and later distinguished research.

As for the visitor who wondered if "you guys" at Lowell are going to be OK—it turns out that everyone at Lowell is, in fact, fine, and the scientific work by astronomers at Lowell and elsewhere has shown that Pluto itself seems to be doing well, too, still orbiting the Sun as it has been doing since well before humans even knew of it and still geologically active. As then-director of Lowell V.M. Slipher wrote to colleague John Miller of Swarthmore College's Sproul Observatory a month after Pluto's discovery in 1930, "It will go right on being just what it is in spite of all we think or say about it or the names we call it."

ACKNOWLEDGEMENTS

This story is the result of more than a century of steadfast scientific pursuit by a variety of people working, often in solitude, to expand our understanding of a small corner of the universe. Numerous people helped—some directly, others unknowingly—to gather the facts and memories to tell this story. We'd like to specifically thank several people here.

For tracking down archival information: Lauren Amundson, Stacey Christen, Roger Serrato, John Spahn and Linda Spahn of Lowell Observatory; and Martha Shipman Andrews, Dennis Daily, Teddie Moreno and Jennifer Chavez of the New Mexico State University Library, Archives and Special Collections.

Many scientists and historians gave their time for specific interviews or general discussion, including Marc Buie, John Spencer, Bob Millis, Larry Wasserman, Ralph Nye, Brian Skiff, Ted Dunham, Amanda Bosh, Stephen Levine, Leslie Young, Cathy Olkin, Bill Sheehan, Dale Cruikshank and Jim Christy.

Several people supplied photographs, and they are listed in the image captions.

One of our goals in putting this book together was to directly involve some of the major characters who have played a part in the Lowell-Flagstaff story. We wanted firsthand accounts of those people—or their descendants—and they graciously contributed as follows: Annette Tombaugh-Sitze and Alden Tombaugh (Clyde Tombaugh's children—Foreword), W. Lowell Putnam (Percival Lowell's great-grandnephew and current sole trustee of Lowell

Observatory—Introduction), Jeff Hall and Gerard van Belle (both are astronomers at Lowell, and Hall also serves as director—Epilogue) and Alan Stern (he also kindly donated his car to be sold at an auction, with proceeds going to the 2017 renovation of the Pluto discovery telescope—Afterword).

The section dealing with Pluto's naming appeared in the March 2016 issue of *Astronomy* magazine, while some other content first appeared in Schindler's biweekly "View from Mars Hill" column for the *Arizona Daily Sun.* Thanks to *Astronomy* editor Dave Eicher and *Arizona Daily Sun* editor Randy Wilson for this use.

Jeff Hall, Mary DeMuth, Larry Wasserman, Brian Skiff and David DeVorkin read parts or all of the manuscript and suggested edits that improved the readability and accuracy of this story.

Laurie Krill at Arcadia Press was magnificent with her thoughtful guidance and patience in seeing this book to completion, and Hilary Parrish, also with Arcadia, oversaw the many edits that made this read better.

Many, many more people contributed to this project with their support, inspiration and/or expertise. We can't name them all here, but of special note are Mike Neufeld, Bonnie Stevens, Emery Cowan, Melissa Sevigny, Randy Wilson, Don Lago, Mike and Karen Kitt, Molly Baker, Sarah Gilbert, Samantha Gorney, Todd Gonzales, Steele Wotkyns, Florence McGuire and Alma Ruiz-Velasco.

Grundy thanks his parents, Marty and Ken, and his partner, Bonny. All of them have been wonderful both in encouraging his pursuit of scientific interests and in tolerating his consequent distraction.

Schindler sends a special shout-out to Robert Leget and Steve Borgis, teachers whose lessons and inspiration resonate louder than ever. Schindler also appreciates the love and outstanding support from Gretchen, as well as Alicia, Addie, Sommer, Brandon, Senna, Lauren, Mom, Donnie, Terry and Kim and their extended families.

INTRODUCTION

The roads by which men arrive at their insights into celestial matters seem to me almost as worthy of wonder as those matters in themselves.
—Johannes Kepler

Several years ago, when someone learned of my association with Lowell Observatory, they immediately said, "Pluto should never have been found. Percival Lowell was looking for a ghost, and Clyde Tombaugh found it for him!" The association between the observatory, its many-faceted founder and the persistent (and clear-eyed) Kansas farm boy whom he never met is a uniquely American story. The connection between the observatory and Pluto has continued for generations of Lowell researchers and their supporters with the additional discoveries about Pluto and its environs that have occurred.

Pluto has always surprised us. Of course, we have only known of it for just over one-third of a Plutonian year, but in that astronomically short period, it has always been a source of new knowledge, and many times it has upset established "understandings." The number of new discoveries surrounding this one body is evidence of how much more there is to learn about the small neighborhood in space we call the solar system.

From the initial searches with their false assumptions, to the nearly immediate recognition that Pluto was "different" than expected, through the discovery of other Kuiper belt objects, Pluto's moons and atmosphere, Pluto kept proving to be more than what people expected. The New

Horizons mission has only added to this "tradition," with its images and data disrupting our current theories and establishing a need to rewrite the textbooks of planetary body formation and activity. The efforts and persistence of those who made New Horizons happen are a modern version of the struggles and challenges the initial discoverers went through—and on about the same timeframe.

Scientists at Lowell Observatory and other research organizations in Flagstaff have been involved in these discoveries and the associated rethinking of planetary evolution. Acquiring new knowledge is never easy and always requires persistence and willingness to accept facts and look for answers that run counter to established theory. For more than a century, Pluto and the efforts to understand it have been teaching us how much more there is to learn and the value of continuing to study and discover. It is an experience likely to be repeated, as our efforts should reveal much more about this surprising body in the next one hundred years. This is both a challenge and an opportunity for all of us, one that is both exciting and daunting. The example set by those in this book who have done so much before us gives us the encouragement to look for more and the anticipation of exciting new discoveries that lie ahead.

<div style="text-align: right">

W. Lowell Putnam
Sole Trustee of Lowell Observatory
Great-grandnephew of Percival Lowell

</div>

CHAPTER 1

AN EXERCISE IN TRIAL AND ERROR

It means a planet out there as yet unseen by man,
but certain sometime to be detected and added to the others.
—Percival Lowell

The year 1902 was a tipping point for a trio of Harvard University graduates whose relationships to one another ranged from close friends to family. The most well known of them was Theodore Roosevelt, who was in the first year of his presidency and leading a countrywide reform movement that included the dissolution of several dozen trusts, regulation of railroad rates and expansion of the United States onto the world scene. Roosevelt would also make his mark in conserving the country's natural resources, an effort that effectively kicked off with an eight-week trip the following year to the American West. He traveled to such iconic spots as Yellowstone in Wyoming and Yosemite in California. He also went to the Grand Canyon in Arizona, becoming the first president to visit Arizona along the way. Little did he know that, while riding a train through Flagstaff on his way to the Grand Canyon, he passed within the shadows of an astronomical observatory that sat atop a hill overlooking the town. The facility had been founded a decade earlier, primarily for the study of Mars.

One of Roosevelt's friends at Harvard was Owen Wister, who reached widespread fame in that year of 1902 with his book *The Virginian*. Like Roosevelt, Wister was fascinated with the American West and dedicated the

book to his old pal Roosevelt. This volume would soon become recognized as the prototypical western novel, a classic that became the basis for a play, several films and two television series. Twenty-eight years after publication of *The Virginian*, a twenty-four-year-old assistant at that observatory on the hill anxiously sat in a movie theater in Flagstaff and watched Gary Cooper starring in a film adaptation of the book. The assistant was desperately trying to keep his mind off the fact that clouds had covered Flagstaff's sky that evening in 1930, preventing him from photographing the planet he had discovered earlier that day and culminating a search whose seeds were sown by the founder of the observatory.

Roosevelt had arrived for his freshman year at Harvard in the fall of 1876, just months after one of the university's most talented mathematics students graduated. His name was Percival Lowell, and while he missed overlapping with Roosevelt at Harvard by those few months, the two would intersect privately—one of Lowell's sisters married a cousin of Roosevelt, and for a time Percival was engaged to Rose Lee, the sister of Roosevelt's first wife, Alice.

Lowell founded his Flagstaff observatory in 1894, making headlines with his controversial proclamations about life on Mars. He would leave several astronomical legacies, including his quest to find a ninth planet he believed lurked in the outer reaches of the solar system. He first mentioned this theoretical planet in a public lecture late in 1902. While it ultimately eluded him, his enthusiasm for the search inspired his successors at the observatory, culminating with Clyde Tombaugh's discovery of Pluto on February 18, 1930.

TO BE A LOWELL

Percival Lowell hailed from one of Boston's elite Brahmin clans, known for its accomplishments in areas ranging from commerce to academia. The family produced more than its fair share of businessmen, judges, writers, industrialists, ministers, philanthropists and architects. The family motto, *occasionem cognosce*, means "know your opportunity," and family members took this to heart in pursuing excellence. To be a Lowell meant not merely relying on the family wealth to sail through life. Instead, family members were expected to assume leadership roles, whether in their chosen vocation or community activities.

Percival was born in 1855, the eldest of seven children (five survived to adulthood, including two boys and three girls). As Percival's brother Abbott noted in his biography of Percival, their father instilled in the children the Lowell work ethic: "Somehow he made us feel that every self-respecting man must work at something that is worthwhile, and do it very hard. In our case it need not be remunerative, for he had enough to provide for that; but it must be of real significance." So was developed the drive and fortitude that would carry Percival through his life and the passion that would feed his desire to succeed and "plow his own furrow," as Abbott put it.

Percival's life would unfold in a manner captured by a passage commonly attributed to Ralph Waldo Emerson (though historians find no evidence that he actually said it): "Do not go where the path may lead, go instead where there is no path and leave a trail." After overseeing finances of his family's milling operations and then making a name for himself by studying the culture of the Far East, Lowell improbably entered the field of astronomy. He was inspired by provocative discoveries relating to the planet Mars that seemed to indicate, at least to some observers, the presence of intelligent beings on that planet.

Lowell was thirty-nine years old at the time and threw his considerable energy into pursuing astronomical research, an arena in which he would remain until his death in 1916 at the age of sixty-one. While most American observatories at the time were located near the more populated regions of the country, Lowell realized the need to move away from such areas if he was going to successfully study space. In his 1906 book *Mars and Its Canals*, he lamented about how civilization, particularly on the East Coast of the United States, was blotting out the sky. "Smoke from multiplying factories by rising into the air and forming the nucleus about which cloud collects has joined with electric lighting to help put out the stars," he wrote. Thus, for his observatory he would head to the lightly inhabited Arizona Territory (statehood didn't come until 1912).

Lowell focused most of his efforts on studying Mars and popularizing the notion of intelligent life on that planet through public speeches, articles in newspapers and magazines and books. But he did expand his research into other areas of the solar system, observing most of the other planets and speculating on their collective origin and evolution. He split his time between astronomical studies at his observatory in Flagstaff; business and family concerns in his hometown of Boston; and miscellaneous travels that often included lecture stops. By all accounts, he was an engaging speaker who usually drew large crowds for his presentations.

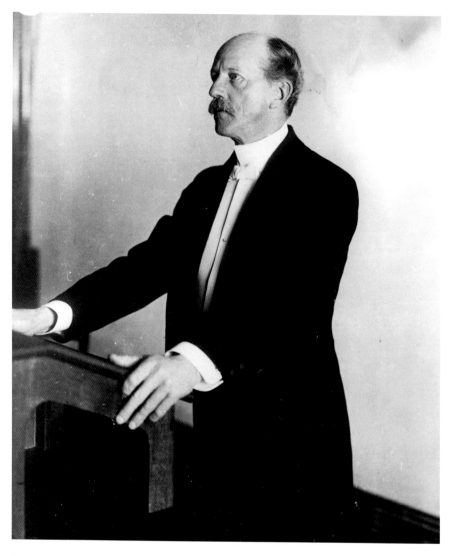

Percival Lowell was a dynamic public speaker. *Lowell Observatory.*

Recognizing Lowell's skill as a lecturer, the Massachusetts Institute of Technology hired him in 1902 as a nonresident astronomy professor. Toward the end of the year, Lowell presented a series of six lectures highlighting the physical and behavioral characteristics of the Sun and its family of planets, moons, comets and asteroids. He then integrated these observations into an explanation about the formation and large-scale structure of the solar system.

A PLANET OUT THERE AS YET UNSEEN

Publisher Houghton, Mifflin and Company saw value in Lowell's lectures and in 1903 compiled them into a 134-page book simply titled *The Solar System*. The content of Lowell's talks was thus preserved, allowing later students the opportunity to participate in the lectures, as it were. Among other items of interest in this volume are Lowell's first written thoughts about a possible ninth planet. He cited two lines of supporting evidence, worth sharing here both to understand his reasoning (modern astronomy gives no credence to either of them, but such ideas were common among many astronomers of the time) and to get a feel for the colorful prose that made his presentations and writings popular with the public.

The first regards the relationship between the orbits of meteor streams and planets. Lowell writes:

> *Another point connected with these meteor streams must be noticed. Each of them is associated with the orbit of some particular planet. The planet in some sense shares with the Sun a control over the stream. It cannot cause the stream to circle round itself, but it can, and does, cause it to pay periodic obeisance to its might. The stream's perihelion remains at the Sun, but its aphelion becomes its periplaneta. It sweeps about the planet at one end of its path somewhat as it sweeps round the Sun at the other.*
>
> *The Andromedes are thus dependent on Jupiter, the Leonids on Uranus; while the Perseids and the Lyrids go out to meet the unknown planet which circles at a distance of about forty-five astronomical units from the Sun.*
>
> *It may seem to you strange to speak thus confidently of what no mortal eye has seen, but the finger off the sing-board of phenomena points so clearly as to justify the definite article. The eye of analysis has already suspected the invisible.*

Later in the book, Lowell points out an apparent connection between the orbits of comets and planets:

> *Jupiter is not the only planet that has a comet-family. All the large planets have the like: Saturn has a family of two, Uranus also of two, Neptune of six; and the spaces between these planets are clear of comet aphelia; the gaps prove the action.*
>
> *Nor does the action, apparently, stop there. Plotting the aphelia of all the comets that have been observed, we find as we go out from the Sun, clusters*

of them at first, representing, respectively, Jupiter's, Saturn's, Uranus', and Neptune's family; but the clusters do not stop with Neptune. Beyond that planet is a gap, and then at 49 and 50 astronomical units we find two more aphelia, and then nothing again till we reach 75 units out.

This can hardly be an accident; and if not chance, it means a planet out there as yet unseen by man, but certain sometime to be detected and added to the others. Thus not only are comets a part of our system now recognized, but they act as finger-posts to planets not yet known.

We have thus examined the case of an old planet, Mercury; of a middle-aged one, Mars; of a youthful one, Jupiter; and we have ended by envisaging the yet unchristened.

Like many of Lowell's ideas about life on Mars, these inferred indicators of the presence of planets, and the very idea that a ninth planet might even exist, were not original to Lowell. In fact, after Neptune's discovery in 1846, many astronomers took it for granted that a ninth planet probably existed. The primary reason had to do with the orbital motion of Uranus. After its discovery in 1781, scientists observed that Uranus exhibited unexpected deviations, or perturbations, in its orbit. They figured this must be caused by the gravitational tugging of another, previously unknown planet. Two mathematicians working independently—John Couch Adams of England and Frenchman Urban Le Verrier—mathematically calculated the position of the purported perpetrator. While the initial disposition of Adams's work has been debated by historians, Le Verrier shared his calculations with German astronomer Johann Galle. With the assistance of fellow German Heinrich d'Arrest, Galle quickly pinpointed the planet that eventually was named Neptune.

Astronomers soon realized that Neptune may not have completely accounted for the perturbations of Uranus and thus figured yet another planet must be out there. Over the ensuing decades, various astronomers carried out half-hearted, unsuccessful searches. Occasionally, an astronomer discovered an object thought to be a planet but eventually proven otherwise.

By the beginning of the twentieth century, most scientists had grown skeptical about the reality of any more planets in the solar system. Lowell himself was initially reserved on the subject; after publication of his *The Solar System* book in 1903, the topic doesn't appear again in his work until 1905, and even then it is just a footnote compared to his detailed Mars writings. But over time, Lowell's interest in a ninth planet evolved from a casual interest to a dedicated search and finally to a dogged pursuit. Like

the canals of Mars, the possibility of a ninth planet seems to have been one of those unconventional ideas that intrigued Lowell, perhaps because of the potential upside of such research. At a time when his most infamous fringe pursuit—the study of potential life on Mars—was coming under increased attacks from more mainstream scientists, Lowell looked to a ninth planet search as a redemptive effort. If he could find a new planet, he would gain credibility with other astronomers.

SETTING THE STAGE

Lowell quietly began his search for a ninth planet in early 1905. His initial plan was to photographically search the skies in the most likely place to find a planet—a zone called the invariable plane, through which the known planets orbited. He needed two things to do this: the proper telescope for taking pictures and someone versed in astrophotography to do the work. Lowell at the time employed only a few assistants, with Vesto "V.M." Slipher and Carl Lampland the only full-time astronomers. Slipher, who had grown up on a farm in Indiana, was a bright young scientist who began working at Lowell Observatory in 1901. He would spend his entire career there and make a number of fundamental discoveries. His greatest contribution to science came when he observed several faint blobs known as spiral nebulae (astronomers now understand them to be galaxies, but this was unknown at the time) that he found to be moving away at high velocities (hundreds of times the speed of sound). These so-called recessional velocity observations provided the first evidence of the expanding nature of the universe. He also served as the Lowell Observatory director for several decades, during which he hired a twenty-three-year-old farmer from Kansas named Clyde Tombaugh to help with a later version of the planet search.

Carl Lampland, from Minnesota, began working at Lowell Observatory in 1902 and, like Slipher, would work there for his entire career. He was a master instrument maker and photographer who built his own thermocouples for measuring temperatures of planets. The house he lived in during most of his five decades at Lowell Observatory still stands and is in regular use as a staff residence. Lampland would eventually help with the planet search, but initially, he and Slipher were occupied full time with other efforts and were not available to devote significant time to the search. Lowell solved this staffing problem by developing a fellowship, in conjunction with Indiana

University (the alma mater of both Slipher and Lampland), that would support graduate students coming to Lowell to gain research experience, specifically on the planet search. Called the Lawrence Fellowship, it paid a stipend of fifty dollars per month, along with lodging.

The Lawrence Fellowship was short-lived, lasting only three years, but it left a legacy that went beyond the planet search. It also set the stage for Lowell Observatory as a place for students to be mentored by professional astronomers while gaining valuable experience in observing and research. This continues in the modern era, with students coming to Lowell via internships, astronomy field camps and other programs. The value of such experience is evident based on the future careers of the three students who worked as Lawrence Fellows. John Duncan, who served from 1905 to 1906, later became a well-respected astronomy professor at Harvard University and Wellesley College. Kenneth Williams, who was the last of the Lawrence Fellows (in 1907), would finish his schooling and then spend the next fifty years as a mathematics instructor at Indiana.

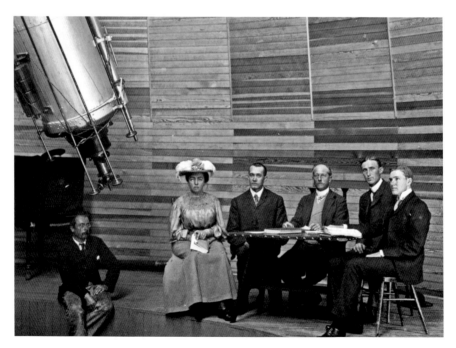

Lowell Observatory staff photo taken in 1905. *Left to right*: Harry Hussey, Wrexie Leonard, V.M. Slipher, Percival Lowell, Carl Lampland and John Duncan. *Lowell Observatory*.

The second Lowell Fellow had a familiar name and would end up at Lowell as a full-time astronomer, spending his entire career there. He was Earl "E.C." Slipher, a younger brother of V.M. After his 1906–7 stint as a Lawrence Fellow, E.C. stayed on at Lowell and became one of the world's leading planetary astronomers, with special focus on Mars. He revolutionized planetary photography and was one of the first people to incorporate multiple image printing, which involved taking several images in close succession and superimposing them on a single photographic plate. Typical of many Lowell Observatory staff members then and since, E.C. was also an active community member, serving as a mayor of Flagstaff and member of the Arizona state legislature, as well as director of Lowell Observatory.

With John Duncan's arrival at Lowell Observatory in July 1905, Lowell had a staff member who could devote his time to the planet search. Now they could focus on finding the appropriate equipment and developing the best photography techniques for planning the effort. This was easier said than done, and much of this initial planet search by Duncan and the other Lawrence Fellows involved testing a variety of telescopes, lenses and observational procedures.

The first telescope Duncan tried was the observatory's flagship instrument, the twenty-four-inch Clark refractor. Referred to by most Lowell staff simply as "the Clark," it was built in 1896 by one of the preeminent telescope makers of the time, the Alvan Clark & Sons firm of Cambridgeport, Massachusetts. Its thirty-two-foot-long tube is housed in a large white dome that still stands, an icon of the Flagstaff skyline and beacon of astronomical pursuits. Percival Lowell commissioned the Clark specifically to observe Mars, and it became the main telescope that E.C. Slipher would use in his long planetary research career. V.M. Slipher used it, in conjunction with the spectrograph, for his groundbreaking recessional velocity research. Decades later, in the 1960s, scientists combined forces with artists to create detailed lunar maps in support of NASA's manned missions to the Moon, while many of the astronauts themselves studied the Moon by peering through the telescope.

The Clark Telescope was, and still is, a fabulous device for exploring the universe, but it was inadequate for Percival Lowell's planet search. The ideal telescope for such work offered a wide field of view that allowed observers to efficiently photograph large swaths of sky (this was done by replacing the telescope eyepiece with an astronomical camera loaded with photographic glass plates and then attaching it to the base of the telescope). After some

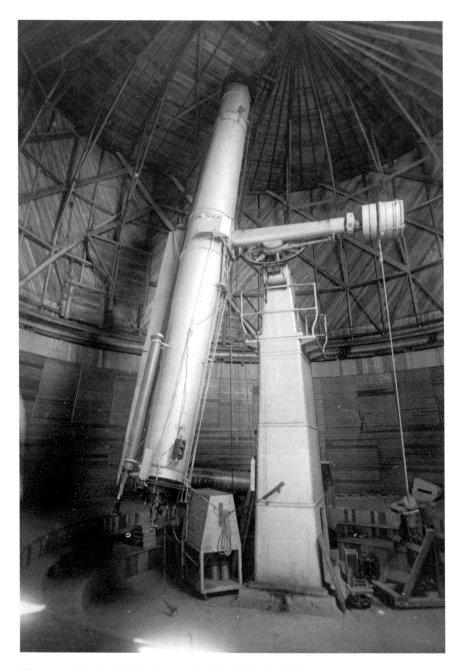

The twenty-four-inch Clark telescope, built in 1896. *Lowell Observatory*.

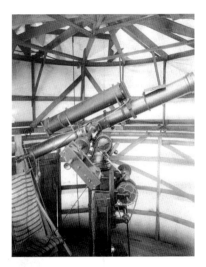

The five-inch Brashear telescope mounted on top of Percival Lowell's six-inch Clark refractor. *Lowell Observatory.*

tests with the Clark in August, Duncan found that the field of view was simply too small, and exposure times too long, for an effective search.

Through the rest of the year, Duncan took test images with a 5-inch Voigtlander lens and Roettger 6⅜-inch lens, but neither of them produced usable plates. In January 1906, Lowell made arrangements to test a 5-inch lens made by John Brashear, a master instrument maker in Pittsburgh who had built Slipher's spectrograph. Duncan experimented with this, the fourth telescope used for the planet search. By making three-hour-long exposures, he was able to detect objects whose faintness was well within the expected range of the theoretical planet. Happy with this news, Percival Lowell bought the lens for $350.

While the five-inch Brashear lens would ultimately prove unsatisfactory for the planet search, it was clearly the most suitable of all instruments tested to that point and would be the primary planet search telescope for several years. For at least some of this work, it was piggybacked onto a six-inch Clark refractor that already had its own unique history. Percival Lowell bought this telescope in 1892 and took it with him on his final trip to Japan, observing Saturn and other objects. When, in 1894, Lowell decided to enter the field of astronomy full time by building his own observatory, he sent the telescope with assistant Andrew Douglass on an expedition to test the skies at various sites around Arizona Territory. This effort resulted in the founding of Lowell Observatory in Flagstaff on May 28, 1894. Douglass later used the telescope for additional site testing surveys, sometimes on the nearby San Francisco Peaks. After its use with the five-inch Brashear for the planet search, it was mounted onto the twenty-four-inch Clark as a finder telescope and stayed there for the better part of a century. Today, the six-inch stands sentry in the observatory's Putnam Collection Center.

To accommodate an extended search with the five-inch Brashear, Lowell directed construction of a small, canvas-covered dome in which it

could be protected from poor weather when not in use. While this dome is long gone, its foundation still stands. It is now overshadowed by Ponderosa pine trees, less than one hundred yards to the northwest of the Putnam Collection Center.

PROGRESS

Through June 1906, Duncan spent much of his time gathering three-hour exposures of segments of the invariable plane. On the plates, the supposed new planet would appear as a small dot, indistinguishable from the myriad background stars. To differentiate a planet, Duncan took a second set of exposures, two weeks after the originals. Nearby objects in our solar system, such as planets, appear to move much faster than the far more distant stars. This effect can be visualized when riding in a car—trees near the road appear to speed by, while the more distant trees on the horizon seem to move much slower. Thus, by taking pictures of the same place some number of days apart, an observer could separate the planetary wheat from the stellar chaff. A problem with this method was that other nearby objects, such as asteroids, also showed movement, so observers would have to develop techniques that distinguished these from planets. Lowell soon modified the photography procedure so that only areas opposite the Sun in the sky (a point called opposition) were photographed. Also, the exposures were repeated at intervals of three days rather than two weeks. This minimized the number of asteroids causing confusion.

Duncan took his last exposure on June 20, 1906. His Lawrence Fellowship ended, and he then returned to Indiana. The search program still continued nearly without pause because Carl Lampland had by now joined the effort, if only for small segments of time. Plus, E.C. Slipher soon came on board as the second Lawrence Fellow, taking his first exposure on July 28, 1906. He continued with the work until April 1907, when he joined an expedition to South Africa to observe Mars. Kenneth Williams soon arrived and took up the planet search work, continuing through September 1907. It was around this time that the photographic search ended.

Planetary expert E.C. Slipher, who spent his entire professional career as an astronomer at Lowell Observatory. *Lowell Observatory*.

MATHEMATICAL SEARCH

Lowell had realized early on that the invariable plane was a large area to photograph and the likelihood of finding a planet somewhere in there was a needle-in-a-haystack exercise. He thus spearheaded a separate effort, starting in 1905, aimed at mathematically pinpointing the position of the theoretical planet. He needed someone steeped in mathematics to help with this, so he contacted the director of the U.S. Naval Observatory's Nautical/Almanac Office in search of a qualified candidate. A man named William Carrigan fit the bill, and Lowell hired him in the spring of 1905 as a "computer." In the days before electronic computers, detailed calculations were often made by humans trained in mathematics and simply called computers. Usually working in relative obscurity, these amazing people—often women—paved the way for immeasurable advances in science and other fields.

The detailed work these computers completed is staggering considering the equipment they had at their disposal: no modern digital calculating devices but, rather, a variety of mechanically operated machines. Computers at Lowell Observatory would use two different devices through the years, both of which remain at the observatory and are usually on public display. The first was a Thacher's calculating instrument, a cylindrical device equivalent to a sixty-foot-long conventional slide rule.

The second was the Millionaire, a motor-driven device. It was superior to other calculating machines of the time because of its rapid speed of operation, allowing users to make eight-digit calculations in less than ten seconds. It remained the most effective calculating device until the arrival of fully automatic rotary calculators in the 1930s.

Percival Lowell, realizing that the orbital gaps of the meteor streams and comets could very well be coincidental, focused his attention on the apparent perturbations of Uranus' orbit. This required him to track down and evaluate past positional measurements of Uranus and Neptune. Carrigan, working in Washington, D.C., spent much of his time doing this very thing, examining the so-called residuals of Uranus and Neptune dating from the late 1700s to the early 1800s. Residuals refer to the difference between where an object actually is and where scientists think it should be, based on assumptions about its orbit. Residuals can be caused by a number of factors, from inaccurate measurements and false assumptions about an orbit to what Lowell was looking for: another body whose gravity is pulling on the object and thus creating a disparity between observed and expected readings.

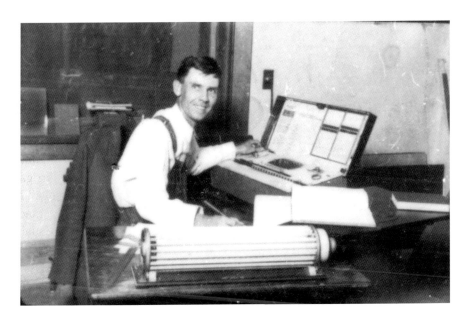

Computer William Carrigan with a Millionaire calculator and Thacher's calculating device, both used for making the Planet X computations. *Lowell Observatory.*

Example of Planet X calculations. *Lowell Observatory.*

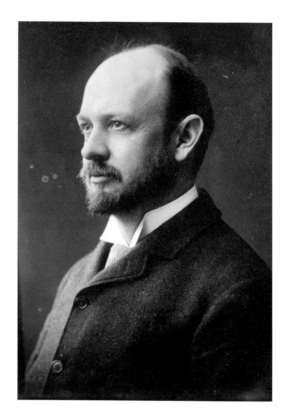

William Pickering, astronomer at
the Harvard College Observatory.
Lowell Observatory.

By the spring of 1908, Carrigan, working off and on, had finished the residual work. The process took longer than Lowell thought it should, so when he directed Carrigan to examine more residuals, he indicated that Carrigan should speed up the process and be less "vigorous." By this time, the planet search effort had slowed in other ways. The photographic search had ended, and Percival Lowell became consumed with other activities— including getting married—that occupied his time.

This sluggish pace changed dramatically in November 1908, when Lowell learned that William Pickering of the Harvard College Observatory had announced his own planet search, with projected positions for what he called Planet O.

Pickering was the brother of Harvard College Observatory director Edward "E.C." Pickering, and they both had advised Percival Lowell when he was planning his new observatory in 1894. Lowell saw William's search effort as clear competition to find a planet. This spurred him to turn his focus back to the planet search. For the next several months, he urged on Carrigan while spending much of his time on the residuals problem. This lasted until

the spring of 1909, when Lowell wrote Carrigan that he had calculated a position for the new planet and would no longer need Carrigan's services.

Lowell's position for the proposed planet proved to be problematic, and he again drifted away from the search effort, focusing his time on other projects. He realized that the search would be much more difficult than he first thought, requiring an approach that better integrated the mathematical and observational aspects of the work, as well as improved techniques for calculating positions, photographing the sky and examining the plates. Thus ended the first phase of Lowell's planet search, going out with a whimper rather than the bang he had hoped to achieve with the discovery of a planet.

CHAPTER 2

INTEGRATING THE SEARCH

That X was not found was the sharpest disappointment of his life.
—Abbott Lawrence Lowell

Percival Lowell was nothing if not optimistic, and in mid-1910, he entered back into the search for what he began calling "Planet X." With renewed vigor, he mapped out a unified plan, better assimilating the mathematical and observational elements. This included bolstering the individual aspects of the search, from bringing on additional assistants to lead a more vigorous, methodical mathematical evaluation to experimenting with different search telescopes until he found one well suited for the photographic work. He also heeded the advice of Carl Lampland to acquire a device that would greatly enhance the plate examination process.

All these steps were crucial in improving the odds of finding a planet, but with this heightened devotion to resources came escalating expectations from Lowell himself. Throughout the seven years of this extended search, he prodded his staff for any signs of success, a practice that bordered on the impatient pleadings of a desperate man. The effort would drive him to the edge of nervous exhaustion, as he withstood the roller coaster of emotions ranging from the peak of hope to the nadir of everlasting disappointment.

Lowell set the stage for this reinvigorated search in July 1910, when he changed the job responsibilities of an assistant in his Boston office, Elizabeth Langdon Williams. Lowell had hired Williams years earlier to help with preparing manuscripts for publication and general office duties.

But she had a talent for mathematics, having studied physics at MIT and graduating with distinction in 1903. She would now serve as the head of Lowell's computer team, which eventually grew to at least five people. In this capacity, she led a more analytical approach to the X problem and proved to be a valued confidante of Percival Lowell. In fact, even after Lowell's death in 1916, Williams stayed on the observatory staff and moved to Flagstaff. She remained there until 1922, when she married observatory astronomer George Hamilton, a Mars researcher. The couple then moved

Elizabeth Williams, a brilliant mathematician who served as Percival Lowell's chief computer for several years. *Lowell Observatory.*

to the Harvard College Observatory station in Mandeville, Jamaica, which was overseen by William Pickering.

For several months, Lowell was focused on this renewed mathematical search, without any attention to telescope observations. This was in line with the earlier search for what became known as Neptune, when John Couch Adams and Urban Le Verrier both devised precise mathematical solutions for the location of the planet before any searching took place. For Lowell, this was probably easier said than done. While he gave it the proverbial college try to focus on the calculations until he could confidently produce a best likely position, his impatience soon took over, and he set his staff in Flagstaff to searching with a telescope, looking in the vicinity of his latest "most likely position." When nothing turned up, he revised the estimates and directed observers to yet another part of the sky. This approach turned out to be quite inefficient, another exercise in hunting and pecking. Yet it did turn up some valuable results, albeit ones unrecognized until after Pluto's discovery years later.

Observations in Flagstaff began in March 1911. Lowell took the occasion of his fifty-sixth birthday—on March 13—to instruct his observers to begin photographing the sky with the observatory's newest telescope. This forty-inch reflector was the fifth used in Lowell's search for a new planet. It went out of operation in the mid-1960s, but its skeleton sits on display just north of Lowell's Steele Visitor Center, while its original dome still stands, retrofitted to serve as the observatory's wood shop. Yet despite this visibility, the history of this quirky telescope—important in the story of Pluto—has not been documented very well and is therefore worth exploring here.

FORTY-INCH REFLECTOR

As early as 1905, Percival Lowell began pondering the purchase of a large reflecting telescope that could be used for planetary photography. He soon contacted optician and telescope maker George Ritchey about the possibility of building an eighty-four-inch reflector, for which Lowell offered a sum of $55,000. Though this particular proposal never came to fruition, Lowell persisted in his quest for a large reflector, and on April 13, 1908, he contracted with Alvan Clark & Sons in Massachusetts to build a forty-inch telescope. Lowell paid $10,800 (half the amount he paid the firm in 1896 for the exquisite twenty-four-inch refractor) for what became

the largest ever Clark-built reflector. It also served as the largest telescope in Arizona for decades.

In considering a site for the new reflector and its dome, Lowell wanted a place in which few trees had to be felled. Additionally, the ground would have to be easily excavated, since the new structure would be down several feet. Lowell first targeted the southern edge of Mars Hill, overlooking the Arizona Lumber and Timber Company's mill (the Days Inn along Route 66 later sat on part of the mill site), but ultimately chose a flat area of land several hundred feet west of the twenty-four-inch Clark dome.

On June 15, 1909, local mason Oscar Dietzman began work on the new dome, and the primary mirror arrived in Flagstaff by train on August 14, 1909. Workers painstakingly installed the mirror into its cell on September 1, and tests of the new apparatus soon followed.

The dome was sunk into the ground six feet so that only the rotating portion was above the surface. Lowell believed this unusual arrangement would both shield the reflector from wind and also help equalize the temperature, which would theoretically reduce image deformation due to temperature-related expansion and contraction of the mirror. Years later, scientists determined that sinking the dome did nothing to help the seeing and, in fact, may have been counterproductive, because the telescope was more susceptible to image distortion from heat coming off the ground.

The dome consisted of a wooden frame covered by chicken wire. Overlaying this was a type of canvas known as cotton duck, which was commonly used in making wagon and truck covers, tents, awnings and temporary shelters. The canvas came in large rolls and, when applied to the dome, was baggy until the first good rain tightened it up. As the staff soon learned, this canvas wasn't exceptionally sturdy and had to be replaced every three to four years. Finally, after nearly fifty years of this time-consuming and expensive method of recovering the dome, shop man Don Shanks devised a more permanent solution. In January 1956, he built hardwood dies to stamp aluminum sheets. These sheets were then applied to the dome and made for a more permanent covering, inspiring the structure's nickname, the "Jiffy Pop" dome, because of its resemblance to the famous popcorn product.

The primary mirror was seven inches thick and weighed 907 pounds. Though the blank was polished to a diameter of forty-two inches by Robert Lundin of the Clark firm, part of the mirror's edge was covered by the mounting ring, resulting in a usable surface of forty inches. In 1925, observatory handyman Stanley Sykes cut the intruding piece of the ring away, making the entire forty-two-inch surface accessible.

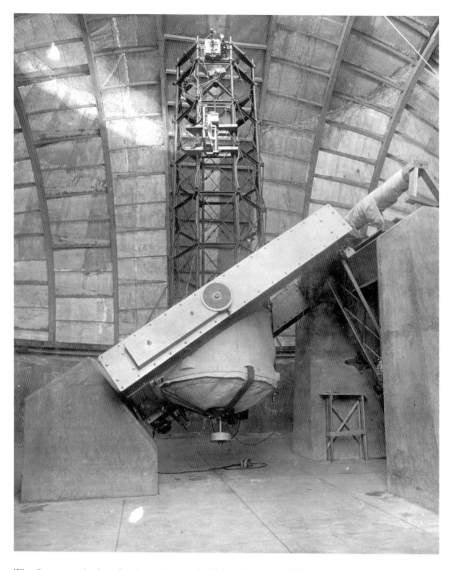

The forty-two-inch reflecting telescope built by the Alvan Clark & Sons firm and used during the second phase of Lowell's Planet X search, as well as post-discovery studies. *Lowell Observatory.*

From the time the telescope was built until the late 1940s, Lampland had virtually exclusive use of it. He photographed galactic and extragalactic objects, studied the Moon and planets spectroscopically and measured the temperatures of planets. In total, Lampland captured more than ten thousand images of planets, variable stars, comets and nebulae.

In 1948, Harold Johnson and Henry Giclas began using the instrument to study planetary atmospheres as part of a new United States Weather Bureau contract. This contract represented a turning point in the life of Lowell Observatory, as it was the first outside contract with a government agency. It began on November 18, 1947, and brought in about $14,000. Part of this grant was for the Solar Variation Project, in which measurements were made of the constancy of sunlight reflected from Uranus and its satellites. This project would continue for decades and produce a useful profile of solar activity not available elsewhere.

By 1964, the telescope was operated only about 20 percent of the available time. To make it more usable for both spectrographic studies and polarization measurements, observatory leaders decided to perforate the primary mirror and convert the instrument into a true Cassegrain system, with the focused light passing through this hole. The work fell to Tinsley Laboratory in California. During sandblasting that would create the hole, the mirror shattered after the hole had reached a depth of about an inch. This accident triggered the acquisition of a new forty-two-inch reflector, the Hall Telescope, which was built at Lowell's dark sky site at Anderson Mesa, a dozen miles southeast of the main Lowell facility on Mars Hill. This instrument went into operation in 1966 and is still an active research telescope today.

In 1999, after decades of dormancy, the framework of the old reflector was removed from the Jiffy Pop dome and put on display behind the Steele Visitor Center. The building itself was converted into the observatory's wood shop. Groundskeeper Jerry McGlothlin and crew turned the old silvering room into a greenhouse and added a second floor.

GEARING UP THE SEARCH

Lampland was happy to use the forty-inch to search for Planet X, though he warned Lowell that it, like the twenty-four-inch refractor, might prove unsatisfactory due to its small field of view. In a September 25, 1912 letter to Lowell, he wrote, "Now in regard to the Planet X problem, you shall have every assurance that the ground will be covered as rapidly as possible with the reflector (40-inch). But if it becomes necessary to photograph a large area, it will take a long time with that instrument; and also, in the great number of plates that must be examined there is considerable danger in

overlooking an object near the edges of the field on account of the elongated images and the small overlap of fields. If then a powerful doublet with a large field could be had it should be excellent for this problem." Lampland nevertheless carried out his orders and spent many nights photographing the sky in search of Planet X.

In retrospect, while Lampland's name is usually reduced to the status of footnote in tales of Pluto's discovery, he proved to be an important player in the effort. To various degrees, he participated in all three phases of the search, from Lowell's first, relatively unsystematic attempts to this second, more organized program and on to the final, culminating drive toward discovery in 1930 and the resulting aftermath. He not only carried out some of the early nuts and bolts photography but also, as discussed later, helped with follow-up observations after Pluto's discovery, searching for possible satellites while also helping determine Pluto's orbit. Perhaps more importantly, he also served as Percival Lowell's primary Planet X confidant and advisor on Mars Hill. He was especially critical on the technical side of the photographic search, encouraging Lowell to acquire the best possible instruments for the work. This included not only trying to find telescopes designed for such wide-field searches but also acquiring a device for examining the plates that was more efficient than merely superimposing them over each other and examining them with a hand lens.

In March 1911, Lampland suggested to Lowell that he purchase a blink comparator machine. Invented in 1904 by German physicist Carl Pulfrich, this specialized stereo microscope held the plates side by side. A mechanical shutter allowed the observer to alternately see first one image and then the other while looking through a microscope eyepiece. This was actually the second time Lampland brought this up, having first mentioned it five years earlier. At that time Lowell demurred, but now, with his dedication to a more thorough and systematic search, he agreed and placed an order with the noted Carl Zeiss optical firm of Jena, Germany. The machine arrived on October 11, and Lampland assembled it that day. It was originally designed to hold six- by seven-inch plates, but Lowell staff found they could more proficiently examine the sky using fourteen- by seventeen-inch plates. Lampland modified the apparatus accordingly by designing slip frames allowing for a quarter of the large plates to be examined at a time.

With this new machine and increased confidence in the mathematical solutions, Lowell's expectations soared. This mirrored his certainty about life on Mars, which he viewed as a foregone conclusion; he knew Planet X was there and only needed to actually find it. His anticipation spread to

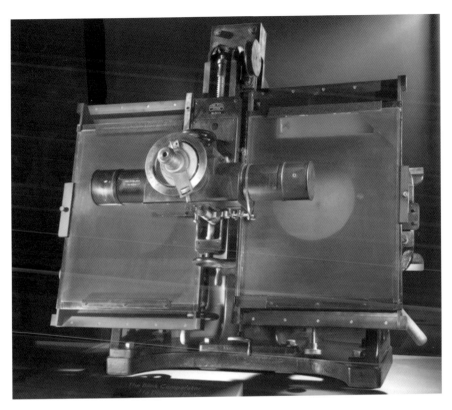

The Zeiss blink comparator machine allowed users to examine photographic plates of the same area of the sky but taken several days apart. *Lowell Observatory.*

other staff and spilled over in their correspondence. On March 22, 1911, Lowell's secretary Wrexie Leonard wrote to Lampland, "It has been a long compilation and Dr. Lowell and Miss Williams have been faithful to it all winter. We feel rather heavy with it but <u>when</u> it is found it will lighten our heart and make us glad!" Nearly two years later, as Lowell was recovering from a bout of nervous exhaustion, he telegraphed Lampland on January 22, 1913: "Examine plates yourself telegraphing discoveries. Rush as planet getting in bad position." On February 8 of the same year, Lowell demonstrated his propensity for word play when he wrote to Lampland, "Please note everything interesting as you may catch other fish and notify us of the haul. Good Luck!" On May 5, 1914, Lowell summed up a telegram to Lampland, "Don't hesitate to startle me with a telegram—FOUND."

Yet for all Lowell's belief in the reality of the planet and his efforts to essentially will the discovery to happen, he kept coming up empty-handed.

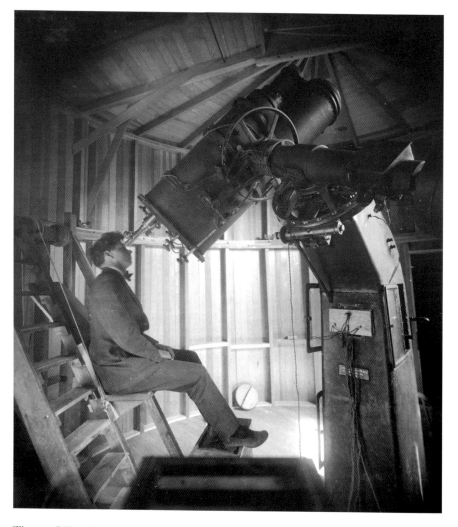

Thomas Gill at the nine-inch telescope with which he unknowingly captured multiple images of Pluto in 1915. *Lowell Observatory.*

After the early 1911 surge in the X search, Lowell's bout with nervous exhaustion, as well as a trip to Europe, took his attention elsewhere for many months. By 1912, he was back to full steam ahead on the project and, working closely with Williams, set about on yet another renewed mathematical push. This was the most comprehensive yet, an all-out assault to determine, once and for all, the most likely position of the theoretical ninth planet. To carry out the daunting calculations in his Boston office, Lowell hired four new computers in November: Thomas Gill, Earl Edwards, Johnson O'Connor

and Herbert Tucker. But while these men learned the ropes of the search, Lowell again became ill, worn down by his intense workload that was grueling both mentally and physically.

While the drama of the X search continued, some of the other observatory staff members did manage to continue with unrelated research. Most notably, as 1912 turned into 1913, V.M. Slipher was experimenting with extremely long exposure times while gathering spectra of so-called spiral nebulae, which many astronomers believed represented sites of planetary formation. Slipher's observations proved revolutionary, as he was able to determine that they were moving at incredible speeds, mostly away from the point of observation. Today, spiral nebulae are known to be galaxies; Slipher's results represented the first evidence that they were moving away from each other, and thus that the universe is expanding. These startling observations brought worldwide acclaim to Slipher from the scientific community.

Lowell congratulated Slipher on this work, but one has to wonder how this truly affected Lowell: the praise Slipher received from fellow astronomers was something that Lowell had craved for years and hoped he would finally achieve with the discovery of Planet X. Now, his own employee was garnering that attention while Lowell continued on the lonely search for Planet X.

In any event, by late 1913, Lowell had entered into what would turn out to be his final big push to find the new planet. After years of slogging through mathematical calculations, his team of computers was narrowing down the potential location of Planet X to the point where Lowell felt confident to share the results with the rest of the scientific world. He had never announced or published such estimates for Planet X before, a fact that seems to indicate his belief in the veracity of the newest results.

UNDETECTED PLANET

By the spring of 1914, the computers were finished, and everyone except Williams left the Boston office. Lowell retained the services of Gill and Edwards, sending them to Flagstaff to learn how to use a nine-inch telescope that Lowell brought in to help with the photographic part of the search.

A year earlier, when Lampland first suggested to Lowell that the forty-inch telescope might be inadequate for the planet search, Lowell decided against bringing in another telescope. But now he thought the time had come to heed Lampland's advice. Besides, Lowell wanted to commandeer

the forty-inch for Mars observations while V.M. Slipher continued using the twenty-four-inch Clark refractor for his important recessional velocity measurements.

In November 1913, Lowell contacted John Miller, director of Swarthmore College's Sproul Observatory, asking Miller if he had a telescope Lowell might borrow. Miller responded by offering the use of a Brashear nine-inch photographic instrument with a forty-five-inch focal length. Built in 1908, its tube was mounted together with two others: one was empty at the time but intended to hold a six-inch lens and the other held a five-inch guiding telescope with a forty-seven-inch focal length. Percival Lowell directed construction of a small dome to house the assemblage. It was located some fifty yards to the east of the canvas-covered structure that housed the five-inch Brashear instrument used in the early stages of the planet search. Like that building, the dome for the nine-inch is gone, but its foundation remains, sitting less than twenty feet southeast of a dome constructed in the 1960s to house a twenty-inch refracting telescope used for moon mapping.

The nine-inch telescope ultimately stayed at Lowell but after years of use became destined for the trash heap. Director of Technical Services Ralph Nye, an avid amateur astronomer when not designing, building and maintaining Lowell's scientific and educational instruments, purchased the dilapidated instrument. He painstakingly rebuilt it, bringing back to life a masterpiece of technology and craftsmanship.

Lowell Observatory staff used the nine-inch for the Planet X search from April 14, 1914, to July 2, 1916. Gill carried out most of these observations, making nearly one thousand plates. Two of them, taken on March 19 and April 7, 1915, would prove of great interest, though not until sixteen years later. As fate would have it, among the thousands of faint, star-like smudges on each of the two plates were images of…Pluto. When staff initially examined the plates in 1915, the images went unrecognized—no surprise given their faintness. After Clyde Tombaugh discovered Pluto in 1930, astronomers developed a tentative orbit that indicated where the planet would have been located in the past. Using this information, Lampland looked in the appropriate position on old images and located Pluto on those March 19 and April 7 plates!

Percival Lowell would go to his grave without ever knowing about the planet. At the time Gill captured Pluto's images, Lowell was preparing his manuscript detailing the results of the mathematical search. It would be published in September under the title *Memoir on a Trans-Neptunian Planet* and essentially represent Lowell's final word on the Planet X work; from

Logbook used by Thomas Gill to record details of his observations with the nine-inch telescope. *Lowell Observatory.*

the time of publication to Lowell's death the following March, he paid little or no attention to it. If he had lived longer, perhaps he would have mounted another attack on the problem or perhaps focused efforts on the photographic search, now that he had narrowed down the possible location of the planet.

Yet did Lowell really believe he had a reasonable solution? In the *Memoir*, he seemed to hedge his bets, not typical of a man who usually shared his ideas with confidence and conviction.

> *Owing to the inexactitude of our data, then, we cannot regard our results with the complacency of completeness we should like. Just as Lagrange and Laplace believed that they had proved the eternal; stability of our system, and just as further study has shown his confidence to have been misplaced; so the fine definiteness of positioning of an unknown by the old analysis of Le Verrier or Adams appears in the light of subsequent research to be only possible under certain circumstances. Analytics thought to promise the precision of a rifle and finds it must rely upon the promiscuity of a shot gun after all, although the fault lies not more in the weapon than in the uncertain bases on which it rests. But to learn the general solution and the limitations of a problem is really instructive and important as if it permitted specifically of exact prediction. For that, too, means advance.*

Percival Lowell published his mathematical estimates of the location of the supposed Planet X in this publication. *Lowell Observatory.*

Whatever the level of Lowell's conviction with the "final" estimates, and whatever further efforts he might have expended on the planet search, the overall effort left him empty. That distant wanderer that he could clearly see with his mind's eye continued to elude his bodily vision. He died on November 12, 1916, never finding it.

Observatory staff members such as Lampland occasionally mentioned the Planet X search in the ensuing months and years, but for the next decade, no further search efforts were planned. The most obvious reason was the death of the project's leader (and financier). In fact, Lowell's death affected much more than the planet search; the very survival of the observatory was in some doubt. Lowell had established a solid endowment to support the operations of his observatory after his death, but his widow, Constance,

Percival Lowell died in 1916, and this mausoleum was later built at Lowell Observatory to house his earthly remains. The structure remains a distinct feature of the observatory's grounds. *Lowell Observatory*.

challenged details of Lowell's will, and the matter was dragged out over ten years, leaving observatory staff with little funding to carry on research. Compounding this lack of financial support was the onset of World War I. This taxed the resources and energies of the entire nation and diverted people's attention away from their normal daily pursuits to more basic issues of survival and supporting the war effort.

According to Percival's brother Abbott Lawrence Lowell, not finding Planet X was the biggest disappointment of Percival's life. Yet the effort, unbeknownst to the desperate astronomer, proved critical to the eventual discovery and understanding of Pluto. While Lowell's search was still dominated by the fluctuating impulses of his obsessive mind, it was more organized and integrated than the initial effort. Later astronomers would build on this improvement, eventually devising a well-planned, systematic search that proved successful. The techniques, assumptions and equipment that Lowell incorporated served as a foundation on which to build the subsequent efforts. Plus, Percival Lowell's very conviction served to inspire those later generations of planet searchers. Had he not spent all those years searching and laying the planetary groundwork, no one else would have seriously looked for a ninth planet, and Pluto probably wouldn't have been discovered until decades later. But Lowell did set the process in motion, and it led to a discovery that revolutionized astronomers' understanding of the solar system.

PRECISION AND PLANNING

We hope this instrument will have a useful career, and that President Lowell will find satisfaction in the results attained through its use.
—V.M. Slipher

By the spring of 1927, Lowell Observatory had been languishing for a decade under the burden of Constance Lowell's court battle over her late husband's will. But the fortunes of the observatory were about to change as this debilitating deliberation finally wound down and observatory leadership enthusiastically set sail on a new era of exploration and discovery.

Percival Lowell had proclaimed in his will that upon his death, a member of his family would assume control of the observatory in a position designated as "sole trustee." Percival chose his third cousin Guy Lowell to take on this role. Guy was an architect best known for designing buildings including the Boston Museum of Fine Arts and the New York State Supreme Court building in New York City. He also was an accomplished landscape artist, working on gardens for the likes of industrialist Andrew Carnegie and financier J.P. Morgan.

Guy served as sole trustee of the observatory from Percival's death in 1916 to Guy's own death on February 4, 1927 (coincidentally, in Kansas a young farmer named Clyde Tombaugh celebrated his twenty-first birthday on this day). Guy had previously designated Roger Lowell Putnam—a nephew of Percival Lowell—as his successor for the sole trustee position. Like his Uncle Percy, Roger graduated from Harvard with a degree in

Left: The second sole trustee of Lowell Observatory, Roger Lowell Putnam, reignited the observatory's search for Planet X. *Lowell Observatory*.

Right: V.M. Slipher, like his younger brother E.C., spent his entire career at Lowell Observatory. He innovated spectroscopic studies of celestial bodies and also served as the observatory's director for several decades. *Lowell Observatory*.

mathematics. He rose to prominence in Springfield, Massachusetts, as the president and chairman of the board for the Package Machinery Company, a product packaging business. He was also a three-time mayor of that community and served in federal positions under Presidents Franklin Roosevelt and Harry Truman. He served as sole trustee of Lowell Observatory for forty years, overseeing an era of unprecedented growth that would eventually turn the observatory into a recognized leader of astronomical research.

Roger took over as sole trustee at just about the time Constance's litigation ended. Wanting to reenergize the observatory after this era of limited optimism and funding, he renewed his Uncle Percy's search for a ninth planet. Such an effort, he reasoned, would galvanize staff and bring positive attention to the observatory if it proved successful. He discussed this with V.M. Slipher, who by now was serving as director, and together they hatched a plan to recommence the search. Slipher devised a systematic and thorough search plan, while Putnam focused on acquiring the resources necessary to carry it out.

This third search was a direct outgrowth of Lowell's earlier efforts. While they came up empty in terms of finding a planet, they ultimately

proved useful for several reasons. First was the spirit of the search itself. Lowell was driven by an overarching belief that discovering a planet would validate the work of his observatory in the eyes of the mainstream astronomical community. Putnam, as mentioned previously, adopted this view as inspiration for resuming the project.

The early searches also laid the technical groundwork for how best to carry out such an effort. Lowell and his staff experimented with different search techniques, from trying various telescopes for making photographs to modifying the procedures for examining the resulting plates. Slipher incorporated lessons learned from these experiments into his plans for the third search. Furthermore, Lowell's solutions for the location of Planet X served as starting points for the third search. This would prove critical, as Clyde Tombaugh's initial efforts focused on these areas of the sky. If not for this guidance, either Putnam might not have even pushed to resume the search or Tombaugh may have started the search in a different area of the sky, delaying the discovery.

THE RIGHT TELESCOPE FOR THE JOB

Putnam and Slipher realized that the telescopes Lowell and his staff used in the previous planet searches weren't ideal; some gave too narrow a field of view, while others lacked the necessary resolving power. With the observatory still recovering financially from Constance Lowell's court battles, Putnam had limited funds available to put toward a new instrument. Conveniently, in 1925 Guy Lowell had purchased a trio of partially figured, thirteen-inch-diameter glass discs from the estate of recently deceased Joel Metcalf. A graduate of the Harvard Divinity School, Metcalf was a Unitarian minister who also made a name for himself in astronomy, discovering several comets and asteroids. He was a master optician who was working on the discs at the time of his death.

With these discs already in hand, Putnam now just had to find someone to finish figuring them and then design a telescope to hold what would be a triplet lens assembly. In a cost-saving move, observatory staff could then build the telescope mount, as well as a dome to house the instrument.

Back in 1894, Percival Lowell had sought the advice of the Harvard College Observatory (HCO) director, E.C. Pickering, regarding his plans to found an observatory. Now, more than three decades later, Putnam

followed suit and arranged a meeting with the current HCO director, Harlow Shapley, to inquire about opticians who could figure the lens. Based on Shapley's advice, Putnam obtained quotes in the spring of 1927 from J.W. Fecker of Pittsburgh and Howard Grubb in Newcastle, England. Fecker was a highly regarded optician who worked on several projects for HCO. He built his first major telescope in 1923, a sixty-nine-inch reflector for the newly established Perkins Observatory at Ohio Wesleyan University near Columbus, Ohio. As an aside, Lowell Observatory would eventually acquire this instrument, whose primary mirror was replaced with a seventy-two-inch Pyrex version in 1965. This instrument would be Lowell Observatory's largest telescope until the advent in 2012 of the observatory's Discovery Channel Telescope (DCT), named in recognition of $16 million in gifts to Lowell from the telecommunications company and its founder, John Hendricks. The telescope's primary mirror spans fourteen feet.

After receiving the bids and discussing them with Slipher, Putnam decided to obtain a third bid, this one from Robert Lundin of the Alvan Clark & Sons lens- and telescope-making firm of Cambridge, Massachusetts. The observatory had a lot of experience with both the company and Lundin himself; Lundin's father also had worked for the company and helped build the observatory's twenty-four-inch refractor, while Robert oversaw construction of the forty-inch reflector used earlier in the Planet X search.

Putnam decided to hire Lundin, and they agreed on a price of $3,500 with an allowance for up to $500 more if needed. The money to pay for the instrument came from Percival's brother Abbott Lawrence Lowell ("Lawrence" to family and friends), who donated $10,000 for construction of the telescope and dome. The instrument was officially designated the Lawrence Lowell Telescope.

While Lundin worked on the lens at the Alvan Clark & Sons facility in Massachusetts, Slipher initiated construction of the dome and mount at Lowell Observatory. He chose as a site a knoll one hundred yards west of the observatory's administration building (now known as the Slipher Building), on land then leased from the U.S. Forest Service. The reasons for choosing the site were as much for business as astronomical reasons; in a March 23, 1928 letter to Roger Lowell Putnam, Slipher wrote, "If we make use of that land there is no doubt about our being able to hold it, but if we should not put some instrument on it we might not be able to prove it necessary to the work the observatory is doing." The observatory certainly made use of the land and later acquired it outright from the Forest Service.

Stanley Sykes headed up the construction team and, for the dome, used a design similar to the one his brother Godfrey devised to build the twenty-four-inch Clark dome. One significant alteration was the addition of an upper floor, where the telescope would be mounted and operated. The wall of the ground-floor level consisted of cement covered with weathered basalt known locally as Malpais rock. On top of this sat a circle of metal wheels, and on top of this was a metal ring, which connected directly to a wooden dome. This then rotated on top of the wheels. Like the dome for the twenty-four-inch Clark, this one featured a tapered—rather than rounded—top, covered with metal sheeting to protect it from rain, snow and harsh sunlight. The ring and other parts had to be made of cast iron, so Sykes worked with pattern maker Edward Mills to build wooden patterns from which the parts could be cast. They then sent them to foundries in Albuquerque, El Paso and Los Angeles, where they were cast into iron.

The crew finished the building in September 1928 and then focused on the mount. Slipher ordered the worm gear—used for precisely moving the telescope in sync with the rotating night sky (tracking)—from the Philadelphia Gear Works. Except for the worm gear, most of the remaining parts of the mount were built in-house. A critical requirement of the mounting was that it had to allow for the telescope to continually track without running into the pier on which the mount sat. This problem is typical of telescopes like

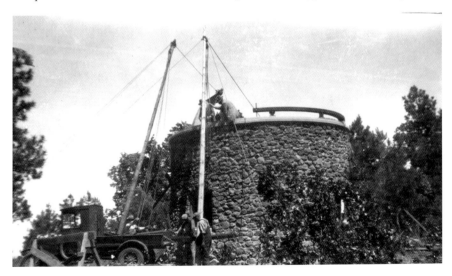

Construction of the dome to house the thirteen-inch telescope that Clyde Tombaugh used to discover Pluto. *Lowell Observatory.*

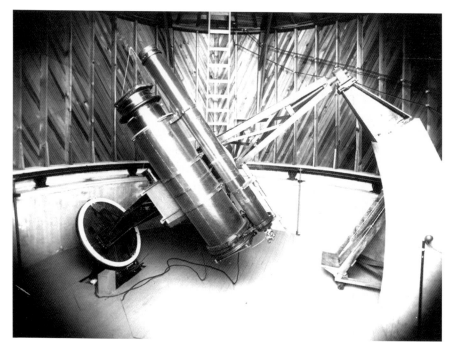

The thirteen-inch telescope soon after it was constructed in the late 1920s. *Lowell Observatory.*

the twenty-four-inch Clark refractor when the telescope is pointing to the north. Sykes thus built a cross-axis mount, in which the mount is long and supported on both ends, rather than from a single central point.

While this construction progressed, V.M. Slipher had been worrying about who would operate the telescope. The small staff of three was already fully subscribed on other projects and wouldn't have adequate time to devote to the resurrected photographic search for Planet X. On May 12, 1928, Slipher wrote to influential astronomer and head of the Princeton University Observatory Henry Norris Russell, asking if he knew about any funding that would pay for an assistant. This request came up empty, so Slipher kept searching for ways to bring on more help. Little could he know that just a few months later, he would receive a letter from a twenty-three-year-old Kansas farmer and amateur astronomer who was seeking a professional evaluation of planetary drawings he had made while looking through his homemade telescope. A better-timed letter could not have arrived in Slipher's mailbox; he began a correspondence with the young man, Clyde Tombaugh, that set the stage for a classic small-town-boy-makes-good tale.

THE RIGHT MAN FOR THE JOB

The eldest of six children, Tombaugh was born on a farm near Streator, Illinois, to Muron and Adella Tombaugh. He learned to work hard at a young age, helping his father cultivate corn, thresh oats and wheat and perform other arduous tasks of farming life.

He also developed a love for reading that would remain with him for life. Early on, he enjoyed exploring geography and history through books. By the time he was a teenager, astronomy had captured his imagination. Clyde's Uncle Lee owned a three-inch telescope and lent it, along with an astronomy book, to the boy. Clyde would later say it was this book that introduced him to people who would become his heroes: Galileo, William Herschel and Percival Lowell.

In 1920, Tombaugh's dad and Uncle Lee bought a 2¼-inch telescope from Sears-Roebuck, an instrument Clyde enjoyed using whenever possible. Two years later, Muron moved his family to Burdette, Kansas, with the hopes of finding better farming conditions. The telescope went with them, and Clyde would spend the next several years scanning the dark Kansas skies whenever time and weather allowed.

When not farming, reading or telescope viewing, Clyde enjoyed sports. He set up a football field and tennis court in the pasture and joined the track team during his last two years of high school before graduating in 1925.

In 1924, Clyde subscribed to the magazine *Popular Astronomy* and became inspired to build his own telescope after reading an article about the markings of Jupiter. His first attempt was an eight-inch reflector that he completed in early 1926. He made a tube out of pine boards and used old farm machinery for the mounting. Not having an adequate facility to properly test the telescope as he ground the glass, the final figure was poor.

After some research, Clyde realized he needed a testing room with a constant temperature in order to properly assess the figure of the glass. He convinced his dad to let him construct a "cave," which could also be used as a tornado shelter and food storage cellar. Using a pick and shovel, Clyde dug a rectangular pit twenty-four feet long, eight feet wide and seven feet deep. With cemented walls and roof, this made an ideal facility for Clyde's mirror-making exploits.

In February 1927, he built a seven-inch reflector—this one with a very good figure—that he sold to his Uncle Lee. With this money, he bought material to build a nine-inch telescope, which he finished early in 1928.

Clyde Tombaugh developed an early interest in astronomy and built his own telescopes while growing up in Streator, Illinois. *Alden and Annette Tombaugh.*

Later that year, the Tombaugh family's crops were ruined by a hailstorm, and Clyde decided to begin looking for a new career, realizing that the farming life was not for him. He soon had an offer to help a Wichita man build telescopes, but before he had the opportunity to accept the job, another offer cropped up.

Tombaugh had been reading some of his older issues of *Popular Astronomy* and saw an observation report of Mars written by Lowell staff. This inspired him to send his drawings to V.M. Slipher at Lowell. After an exchange of several letters with Slipher, Tombaugh received one dated January 2, 1929, that would profoundly change his life. The entire letter is worth sharing here, as it gives valuable insight into the modest job offer and conditions under which Tombaugh would work:

> *Your letter of December 28 has been duly received. And we note your eagerness to get into actual observatory work. We are more in need of help now than ever before and we are willing to have you come here on trial, for a few months at least, because we feel that you should be able to make yourself useful in some capacity about the observatory. We suppose you have had some experience in photographic work or that you are willing to make a special effort to make yourself acquainted with it and with such other work about the observatory as may from time to time be required. For a while at*

least help is needed about the janitor work etc., and it seems to us you should be able to make yourself really useful to us. Under the circumstances that we have not been able to see you and discuss matters with you and we have not yet been able to confer with people who know you, it is not possible for us to offer you at this time any definite or permanent place. But from you[r] letter I am sure that you appreciate the situation and that you are willing to come on the offer of a few months employment that will at the same time enable you to show that you can make yourself useful to the observatory in its work. I am sure I do not need to tell you that there are [sic] lots of hard work and a good many long and some uncomfortable hours at night with the instruments. But if one is interested in the work and is not averse to working hard there are compensations in it aside from the living it affords. There are other things to be sure which one can do and find better pay; but to us interested in astronomy they do not have the satisfying interest that we find in the study of this science.

You may come as soon as you conveniently can. If you need money advanced to meet traveling expenses you might telegraph us if desirable to save time. We think you ought to be able to earn the higher wage that you mentioned in your letter. It will probably be possible to arrange a room for you here at the observatory which would save paying room rent in town, and it would be more convenient especially when doing night work. We can go over these matters better after you arrive, but I thought you might care to bring (if convenient) some bedding and linen with you if you knew such would be useful to you. Of course any such can be got here that may be needed. The room will have the more necessary furniture including bed and mattress. The observatory is about a mile from the business part of town. If you will let us know what train you will arrive on we will meet it, or you can telephone us from the station here.

Slipher was vague about the nature of Tombaugh's duties, but no matter; Tombaugh was thrilled with the offer and accepted the job immediately. Two weeks later, on January 14, 1929, he left home and caught a train for Flagstaff. As Clyde boarded the train, Muron imparted fatherly advice to his son: "Clyde, make yourself useful and beware of easy women." Clyde arrived in Flagstaff the next day and started a new career that would bring him worldwide fame and change the course of astronomical history.

THE JOB

To earn his monthly salary of $125 plus living quarters on the second story of the observatory's administration building (known today as the Slipher Building), Tombaugh shoveled coal and wood into the administration building's furnace, cleared snow off telescope domes and presented the daily afternoon tours to visitors. While he certainly expected to also help out with telescope observing and other astronomical pursuits, he was surprised to learn from Slipher that he would play an important role in the search for a ninth planet, Percival Lowell's fabled Planet X.

Against the backdrop of this pending search, Tombaugh adjusted to working at the observatory and living away from home for the first time. Other staff members showed him the different observing facilities, including the dome that had been built several months earlier but still sat vacant as Robert Lundin finished the lens of the telescope. Eight days after Tombaugh arrived, on January 22, Lundin declared he was done and soon shipped the lens to Arizona. The total cost came in at $5,667.41, substantially higher than the $4,000 cap Putnam had set. Lundin and Putnam ended up splitting the difference, with Putnam paying a total of $4,883.70.

The finished, three-element lens arrived in Flagstaff on February 11, 1929. It measured 13 inches in diameter and, when installed in the telescope tube, made for a powerful astrograph (a telescope designed specifically for taking pictures) with a focal length of 66.5 inches. After much experimenting with different brands and sizes of glass plates on which to expose images, staff decided on 14- by 17-inch ones that captured an area of sky measuring about twelve by fourteen degrees, which roughly equates to the size of a human fist held at arm's length. With one-hour exposures, the instrument yielded images as faint as seventeenth magnitude. (Magnitude is a scale of brightness; the higher the number, the fainter the object. The astronomers figured the new planet would be a good deal brighter than seventeenth magnitude so should be visible within the range of this limiting magnitude.) The plates would typically capture from about 50,000 to 500,000 stars, depending on the area of sky photographed. Places exceptionally dense with stars, particularly those in the middle of the Milky Way galaxy, could yield a mind-boggling million stars on each plate.

Staff spent several days installing and adjusting the lens and took the first exposure on February 16. They then spent several weeks testing and making more adjustments as weather allowed. Slipher, who knew a thing or

two about capturing high-quality images on photographic plates, brought a sense of consistency to this phase of the planet search that was often lacking in earlier efforts. He realized that to best compare pairs of plates, they had to be exposed, developed and examined under as uniform conditions as possible. This required standardizing the procedures so that, for instance, exposures were made under similar atmospheric circumstances and the plate pairs were taken at about the same time of night to ensure a consistent angle. Other problems to resolve included fogging from moonlight (this led to the practice of taking exposures only on moonless nights); abundant planet suspects that always had to be checked, despite the fact that they almost always (with one notable exception) turned out to be an asteroid; variable stars that were visible one day but too faint to make out several days later; distortion of images on the plates; and specks of emulsion on the plate that superficially resembled real astronomical objects.

Another issue that required some ingenuity to resolve was warping of the plates. This resulted in inconsistent images on the pairs of plates, making them difficult to compare. Slipher designed a special "focusing table" that allowed the scientists to assess the level of warping and then adjust it using pressure screws set in the back of each plate holder. This system worked well, though in cold weather the plates, under pressure from the screws, sometimes broke.

By early spring of 1929, Lowell staff had worked out many of these bugs, while Tombaugh would solve others in the following months as he mastered taking exposures. With the commissioning phase of the instrument essentially over, Tombaugh officially kicked off the third phase of Lowell Observatory's planet search on April 6, taking an exposure in the constellation Cancer. This involved Tombaugh loading a plate into the astrograph and then peering through a seven-inch refracting "guide scope"—attached to the main instrument—that allowed him to ensure that the astrograph was holding steady on the objects being imaged. Tombaugh typically took three plates of the same area, spread over a week, using the best two for examination on the blink comparator. The third one could then be used to check any planet suspects detected on the other two plates.

In addition to the guide scope, staff also soon attached a five-inch Brashear camera, loaned by Wilbur Cogshall of Indiana University. It was first used in the search on June 1, 1929. This instrument used eight- by ten-inch plates, which served as backups to the main fourteen- by seventeen-inch ones. If an observer detected a planet suspect on the large plates, he could then check the smaller ones to confirm the nature of the object.

Tombaugh at the guide scope for the thirteen-inch search telescope. *Lowell Observatory.*

In the early stages of the search, Tombaugh's role was limited to making the exposures on the glass plates. The senior astronomers, who all had experience examining glass plates, would theoretically then carry out that portion of the project. Tombaugh photographed the Gemini region of the sky, one of the places where Percival Lowell thought Planet X would be

located. While he did obtain some images, they were of poor quality because of Gemini's low position in the western sky, causing the stellar images to be distorted. He would have to wait until the following winter, when Gemini was again in a favorable position to be photographed. In the meantime, he focused on other areas of the sky, and by the time the annual monsoons arrived in July to cloud out nighttime observing, he had made about one hundred usable plates. However, few of them were examined by the other staff, since they were all busy with their own research or not even in town (E.C. Slipher was in Phoenix at the time, serving in the state legislature).

Thus, V.M. Slipher now instructed Tombaugh to take advantage of the downtime during the rainy season and assume the daunting task of plate examination. He soon mastered both the photographic and plate examination aspects of the planet search, setting the stage for the defining moment of his career, one that resulted in his ascension to the pantheon of astronomy.

CHAPTER 4

PAYDIRT

Young man, I am afraid that you are wasting your time. If there are any more planets, they would have been discovered long before this.
—as told to Clyde Tombaugh by an astronomer

By January 1930, Clyde Tombaugh had been working at Lowell for a year and had settled into a routine. On clear, moonless nights, he made photographic plates of selected areas of the night sky. This required long, tedious hours in which overcoming the boredom of guiding the telescope played as big a role in successfully capturing images as mastering the technical aspects of the operation. In a March 2, 1930 letter to his parents, Tombaugh wrote, "My consolation used to be: 'The longest night has an end' but now it is: 'The longest exposure has an end,' when one is guiding in a cold, dark dome, and one's mind craves for something to occupy its attention, because guiding becomes rather a habit performed subconsciously."

During the day, Tombaugh used the blink comparator to examine pairs of these plates taken several days apart. His job was to look at every image from one plate to the other and see if it changed position. Most did not, but those that did represented a possible planet that moved relative to the background stars. Later in life, Tombaugh estimated he spent seven thousand hours at the blink comparator eyepiece during his fourteen-year career at Lowell Observatory, an average of five hundred hours per year or sixty-three full working days.

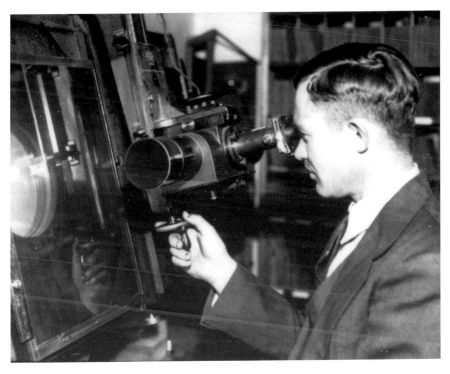

Tombaugh peers through the Zeiss blink comparator, the machine he used to discover Pluto on February 18, 1930. *Lowell Observatory.*

If tracking the telescope was tedious, staring at hundreds of thousands of dots through the eyepiece of the blink comparator for hours on end was nothing short of mind-numbing. Yet Tombaugh worked hard to overcome these mental challenges, as well as ongoing technical difficulties that required attention. The only thing he really couldn't control, as astronomers before and since have also lamented, was the weather. But his days as a farmer prepared him for this and allowed him to draw parallels between astronomy and farming. In a February 23, 1930 letter to his mother, he wrote, "Both farming and star-searching depend on the weather, but the difference is that: 1. In farming you get the work alright, but may lose your pay. 2. In star-searching, you get your pay, but may lose your work."

As Tombaugh kicked off the new year 1929, Gemini was back up in the sky, much higher than when he first tried photographing it the previous year. This would allow him to produce much better plates. On January 21, 23 and 29, with the Moon out of the sky, he photographed an area centered on the star Delta Geminorum. He wasn't able to start examining them until the

following month when, on February 15, he placed the January 23 and 29 plates onto the blink comparator. Over the next few days, he examined the plates when not working on other projects.

Tombaugh prophetically wrote his father a letter on February 16, telling him, "This lunation I invade the region where Pickering's calculations of planetary perturbations lead [*sic*] him to place a trans-Neptunian planet. I am quite a little interested and hope to definitely settle the question within three weeks." Little did Tombaugh know that only two days after writing these words, he would, in fact, settle the question.

A DAY LIKE NO OTHER

Tuesday, February 18, 1930, started out as a typical day for Tombaugh. He woke up at about 7:00 a.m. and drove down Mars Hill to downtown Flagstaff. He picked up the observatory's mail at the post office, then located in the Nackard Building on North San Francisco Street (Arizona Handmade Gallery and Aspen Sports later occupied this building). Tombaugh then headed to breakfast at his favorite restaurant, the Black Cat Café. The building that housed the Black Cat later was home to the Hong Kong Café and Karma Sushi Bar & Grill.

Tombaugh returned to the observatory and by 9:00 a.m. was in the blink comparator room, settling in for another day of examining the January 23 and 29 plates. He spent three hours at the comparator that morning, occasionally taking breaks from the blinking. Without these breaks, the images began to look blurry and his concentration faltered.

At noon, Tombaugh drove to the café for lunch and returned by 1:00 p.m. for another lengthy session of blinking. At about 4:00 p.m., he noticed a faint image changing position about 3.5 millimeters from one plate to the other. He had been doing this blinking business long enough to know when he had an obvious planet suspect, and this definitely was one. With mounting excitement, he spent the next forty-five minutes taking measurements and checking the backup set of plates taken with the five-inch telescope. He also examined the third plate of the group, taken on January 21. Sure enough, the images were also on these plates, in the exact expected position.

Tombaugh called in astronomer Carl Lampland from across the hall to study the plates and then hurried to V.M. Slipher's office. With as much composure as he could muster, Tombaugh announced, "I have found your

DISCOVERY OF THE PLANET PLUTO

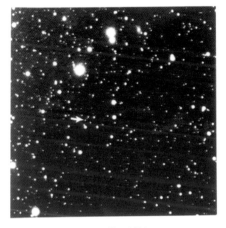

January 23, 1930

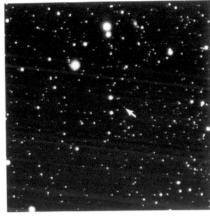

January 29, 1930

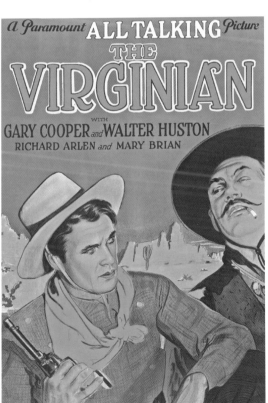

Above: Images of the Pluto discovery plates, with a small arrow indicating the position of Pluto on each plate. *Lowell Observatory*.

Left: Movie poster for *The Virginian*, which Clyde Tombaugh watched the night he discovered Pluto. *Kevin Schindler*.

Planet X." They rushed back to the blink comparator room and clustered around Tombaugh's work area. After close examination, Slipher instructed Tombaugh to re-photograph the object that night with the twenty-four-inch Clark refractor. It would be one of the most excruciating nights of young Tombaugh's life.

At about 6:00 p.m., Tombaugh drove to town, repeating his usual trip of picking up mail and eating at the café. After his meal, he dashed outside and was aghast to see clouds covering the sky. How do you pass time and keep your sanity, knowing that you are close to becoming only the third person to ever discover a planet?

First, he went to the town's only movie theater, the Orpheum, and watched Gary Cooper starring in *The Virginian*. After leaving the theater, Tombaugh saw that the sky was still shrouded with clouds. He drove, exasperated, back to the observatory, sorted mail and tried reading. Hoping to will the clouds away, he loaded photographic plates in their holders in anticipation of some clearing, but alas, the clouds refused to move. By 2:00 a.m., the Gemini area of the sky was too far west. Moreover, the nearly third-quarter Moon would have washed out the sky by that time, even if the clouds did clear up, so Tombaugh called it a night. Of all the days he would live in his ninety-plus years, none would be like this one.

HEADLINE NEWS

Slipher told Tombaugh to keep quiet about the discovery until the staff could further study the new object and confirm its planetary nature. Tombaugh took this to heart and, true to his midwestern roots, kept his word. Even in letters to home he avoided mentioning the big news. The closest he came was an oblique mention in a March 9 letter to his sister Esther. "Well," he said, "last week has been one hurry and bustle." He then commented on the next set of photographs he was planning in between the lunar phases but said nothing about discovering a planet.

Tombaugh and the rest of the staff worked furiously to gather as much data as possible about the new planet. Tombaugh took more plates with the thirteen-inch astrograph and also photographed the new object with the twenty-four-inch Clark, while Lampland imaged it with the forty-two-inch. The observations were still critical, because Slipher wanted not only to confirm that the body was orbiting beyond Neptune but also determine

its orbit. This was only possible by measuring its movement over as many days as possible. Tombaugh stopped blinking so Lampland could use the blink comparator for these position measurements; in fact, Tombaugh didn't resume blinking until May 26. None of the Lowell staff—the Slipher brothers, Lampland or Tombaugh—had any experience calculating orbits, so they discreetly contacted several colleagues from other observatories, including John Miller, John Duncan and Wilbur Cogshall, to help.

By mid-March, the scientists hadn't yet worked out an orbit but otherwise felt they had enough evidence to justify announcing this object as a new planet. The question now became, "When should we tell the world?" Observatory staff chose March 13 because that would have been Percival Lowell's seventy-fifth birthday, a fitting tribute to the man whose inspiration led to the discovery of this new planet. Furthermore, William Herschel discovered Uranus on March 13, 1781.

On the evening of March 12, Lowell director V.M. Slipher sent a telegram to the Harvard College Observatory. From this, officials created *Harvard College Observatory Announcement Card 108*, which officially announced the new planet's discovery when circulated the following day.

Slipher wrote a more detailed account of the discovery and printed it as a *Lowell Observatory Observation Circular*, also releasing it on the thirteenth. Astronomer Carl Lampland was busy on this day as well. On behalf of the observatory, he presented the Lowell Prize to the top mathematics student at Arizona State Teacher's College in Flagstaff (today known as Northern Arizona University). The ceremony took place in front of an audience of five hundred at Ashurst Hall. As part of his speech, Lampland made the first public announcement of the new planet's discovery. Unfortunately, few—if any—of the audience members heard this important message, since the soft-spoken Lampland could not be heard in the uncarpeted, echo-filled room.

Once the story hit the newswires, observatory staff spent most of their time handling the glut of calls, telegrams and visits from the media, astronomers and others. Newspaper headlines from around the world lauded the discovery, and the name Flagstaff was soon famous.

In Burdett, Kansas, the Tombaugh family finally learned of the discovery, but not from Clyde. Muron explained the details in a congratulatory letter to his son dated March 16. He wrote, "Well, well. You old headliner—how does it feel to be a hero in the public eye? Ha, you sure took us by surprise keeping mum about your find until it was proven a fact.

"Friday morning [March 14] we were sitting around the house after breakfast when the phone rang, *Tiller and Toiler* [the county newspaper]

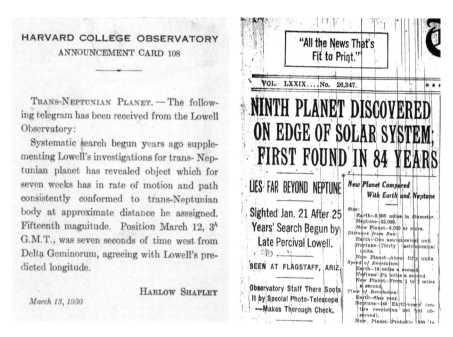

Left: Harvard College Observatory announcement card declaring Pluto's discovery. *Lowell Observatory*.

Right: *New York Times* headline announcing the discovery of Pluto. *Lowell Observatory*.

calling, 'Did you know your son has discovered a planet?' 'No,' says I, 'but I knew he was hot on the trail of one.'"

The envelope with Muron's letter also contained a separately written note from Clyde's mother, Adella. She wrote, "Well! Well! Well! Just 14 months ago last Friday you left for Flagstaff and about 9 o'clock on said Friday morning we heard the grand good news. We are all so happy and glad, but really cannot realize it all yet and I wonder if you can. I cannot be satisfied till we get a letter from you."

The family celebrated in a manner one might expect from a humble, small-town farming family; in Muron's March 16 letter, he explained, "Planted potatoes Saturday am and all went to Larned [in] pm for a little celebration in your honor. We bought all the papers we could find having articles about you, including *K.C. Star* and *Times*, *Wichita Beacon* and *Eagle*, [and] also ordered Sunday editions of the *Star* and *Journal Post*."

Clyde received many other congratulatory notes from family members and strangers alike. He wrote in a March 24 letter to his sister Esther, "Have received letters all the way from asking how to make telescopes to

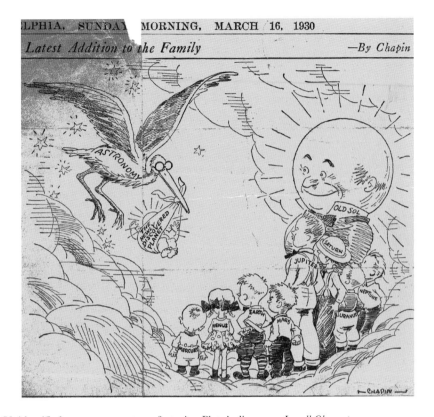

Unidentified newspaper cartoon featuring Pluto's discovery. *Lowell Observatory.*

genealogies. Have received letters from Tombaughs in Texas, Florida, Ohio, and Pennsylvania." He went on to describe a rather amusing note from a stranger in Texas, a girl who was "hinting at a proposal."

DETERMINING AN ORBIT

Astronomers from around the world flooded the observatory with requests for the positions of the planet so they could determine its orbit. Slipher had positions from the January 23 and 29 discovery plates, as well as the January 21 back-up plate, but he still wanted the observatory to generate the initial orbit and so did not share the data. This drew the ire of several astronomers, but Slipher held firm. He later explained his reasoning in an April 18, 1930 letter to Armin Leuschner, director of the Students'

Observatory housed at the University of California–Berkeley (the facility has since been renamed the Leuschner Observatory in his honor). Slipher wrote, "It seemed best for the observatory and those most deeply concerned for us to find it out and make it known if the object were less important than it appeared. Lowell Observatory had put so much into this problem during the last quarter century as to justify the policy."

Slipher could only hold out for so long, as astronomers elsewhere were now making their own observations and gathering position data. Meanwhile, a Harvard student was able to secure one of Lowell Observatory's secretly held positions. Harvard College Observatory director Harlow Shapley explained in an April 5 letter to Roger Lowell Putnam, "One of the young men at the Harvard Observatory who was at the talkies the other night saw a newsreel in which Dr. Slipher was pointing at a photograph telling where the planet was on March 1. He rapidly plotted the field and position, compared with star charts when he got back to the Observatory—or rather with photographs from the region—and handed me the position. Possibly the first newsreel position of an astronomical object that has been obtained."

The same day Shapley wrote the letter, Leuschner and his graduate students Ernest Bower and Fred Whipple announced positions for an orbit based on observations they had made at California's Lick Observatory over a three-week period spanning mid-March to early April (Lowell Observatory didn't release the new planet's orbit until April 12). Nearly a month later, astronomer Andrew Crommelin of the Royal Greenwich Observatory in England identified the planet on a plate taken on January 27, 1927, in Belgium. This extension back in time allowed him to compute an even more accurate orbit. Astronomers could use this enhanced orbit as a guide for where to look on old plates for the planet, and many sightings soon turned up.

One image was found at Lowell Observatory, on a plate Tombaugh took on April 11, 1929. This was one of the exposures he had taken early in the search (it was only his tenth plate), when Gemini was low in the sky. While the plate images were poor, the planet was visible and its position could be measured. Carl Lampland also found the planet on plates taken by Thomas Gill with the observatory's nine-inch telescope on March 19 and April 7, 1915. They had previously gone undetected because of their faintness and the primitive nature of the observatory's search efforts in 1915. Had those images been properly identified in 1915, Percival Lowell would have experienced the satisfaction of leading an effort that resulted in the discovery of a planet. But it was not to be.

WHAT'S IN A NAME?

While scientists were focused on determining the new planet's orbit and its place among the other planets, the public's interest in the discovery was more basic; they wanted to know what to call it. For several weeks, the new planet was frequently discussed both in the media and privately, yet it had no name. People were captivated by this mystery, and many sent their suggestions for a name to Lowell Observatory. This made the discovery personal, something that people could themselves feel part of, and the planet became as much a cultural as scientific entity, a phenomenon that continues to this day.

Hundreds of letters and telegrams quickly overwhelmed observatory staff. This correspondence, much of it preserved today in Lowell's Putnam Collection Center, offers valuable insight into global issues and prevailing thoughts of the day while revealing the personalities of many of the individuals submitting ideas.

One of those who suggested a name was Venetia Burney, a schoolgirl from England who enjoyed learning about mythological characters. On the morning of March 14 while Venetia ate breakfast, her grandfather read to her a newspaper account of the planet's discovery. After thinking about the news and reflecting on her knowledge of mythology, she said Pluto, the god of the distant, cold underworld, was an appropriate name for this dark and gloomy place. Her grandfather, unbeknownst to Venetia, sent Venetia's suggestion to the British astronomer H.H. Turner, who then telegrammed it to Lowell Observatory.

This note would be one of hundreds received by the observatory but stands alone in importance, as indicated in the last paragraph of the May 1, 1930 *Lowell Observatory Circular*. V.M. Slipher wrote, "It seems time now that this body should be given a name of its own. Many names have been suggested and among them Minerva and Pluto have been very popular. But, as Minerva has long been used for one of the asteroids it is really not available for this object. However, Pluto seems very appropriate and we are proposing to the American Astronomical Society and to the Royal Astronomical Society, that this name be given it. As far as we know Pluto was first suggested by Miss Venetia Burney, aged 11, of Oxford, England."

That part of the naming story is well documented in history books, but the roughly six weeks between the March 13 announcement of the new planet's discovery and the May 1 declaration were frenetic for Slipher and his colleagues. While they tried to focus on astronomical issues relating to

Left: Eleven-year-old Venetia Burney is credited with first suggesting the name Pluto for the new planet. *Lowell Observatory*.

Below: Telegram, with Venetia Burney's name grossly misspelled, sent to Lowell Observatory with suggestion of name Pluto. *Lowell Observatory*.

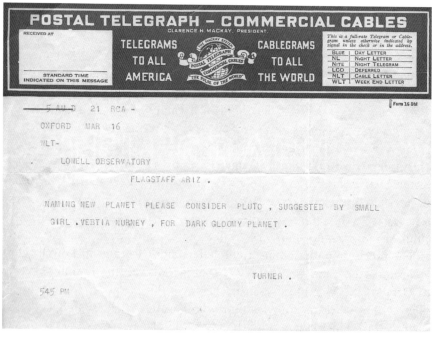

the new planet, such as an orbit determination, they were distracted by the public's surging demand of what to call it.

Media bombarded Lowell staff with inquiries about the name while letters and telegrams continued to pour in from individuals and organizations, offering congratulations on the discovery and suggestions for its designation. This interest was compounded when Lowell trustee Roger Lowell Putnam was misquoted by a reporter as saying the observatory would welcome suggestions for the name. Publications from the *Boston Herald* to the *San Francisco Daily News*, *Popular Science Monthly* to *Christian Science Monitor* carried this story, prompting even more people to join the planet-naming craze.

Newspapers and other entities also held contests. Delia Grace Valancourt of Champaign, Illinois, informed the observatory that she had won such a challenge put forth by the *Chicago Herald and Examiner* for her suggestion of Athene, the Greek goddess of wisdom, while Monckton Dene of South Haven, Michigan, wrote four different letters directly to the observatory in hopes of enhancing his chances of winning a five-dollar prize.

Meanwhile, the Paramount Theater in New Haven, Connecticut, ran a naming contest in conjunction with the *New Haven Times*. Paramount's advertising manager, Ben Cohen, wrote to the observatory, "The sponsors were not so presumptuous as to promise that the winning name would be given to the new planet. They did promise, however, that the winning names would be forwarded to you for your consideration. Therefore, we respectfully submit to you the contest winning name for the new planet representing the choice of 200,000 people: Minerva. This name was chosen from the list of 1,000 sent in by contestants by a committee consisting of the editor of the *New Haven Times*, the manager of the Paramount Theatre and Dr. Frank Schlesinger, professor of astronomy at Yale University."

Newspapers and magazines published many of these contest-winning names plus scores of others. For example, a story ran in the August 1895 issue of the *New England Magazine* citing a suggestion published in the *Chicago Daily News*: "For this notable cosmic catch completing the big-league planetary nine, it would be fitting to call the starry outfielder Babe Ruth." By then, Ruth was winding down his baseball career but still a larger-than-life figure.

The precise number of incoming letters and telegrams to Lowell is lost to history. According to a June 23, 1930 letter from the Lowell secretary to Dene, the "observatory received literally 100s of letters and telegrams offering suggestions. Out of this number, some one hundred and fifty suggested that the name 'Pluto' be given the planet." With the circus-like

UNITED STATES SENATE
WASHINGTON

March 31, 1930.

Lowell Observatory,
Flagstaff, Arizona.

Dear Friends:

Your discovery of the Trans-Neptunian
Planet is an epic which marks an epoch and
has brought world-wide fame to the Lowell
Observatory.

Your friends are delighted that, after
so many years of patient and intelligent vig-
ils, such remarkable success has come to you.

When the time shall have arrived to name
this Planet, if you do not name it Percival,
I would humbly suggest that you retain the
Olympian nomenclature and call it after Athena
or Minerva, who sprang from the brow of Jupiter.

With congratulations and regards to all in
which Mrs. Ashurst heartily joins,

Sincerely yours,

HENRY F. ASHURST.

Letter from U.S. senator Henry Fountain Ashurst suggesting a name for the new planet. *Lowell Observatory.*

atmosphere surrounding the naming, one can imagine that staff simply threw away much of this correspondence.

Of the more than 260 letters that remain at Lowell, at least 117 were written by males and 86 by females. Many of these people added fragments of biographical information, so we know the age range stretched from eleven to seventy-eight years and consisted of students and teachers from elementary school through college, attorneys, ministers, a United States senator (Henry Fountain Ashurst of Arizona) and even a lieutenant commander of the U.S. Navy (Walter Wynne).

The letters and telegrams came from thirty-seven of the then-forty-eight states (plus Alaska), with the most from Massachusetts (forty-nine), New York (thirty-six) and Pennsylvania (twenty-four). Suggestions also arrived from

Canada, Germany, Korea, England and Mexico. A total of 171 different names were proposed, with 13 listed at least five times:

Pluto (Roman god of the underworld), twenty-five nominations
Minerva (Roman goddess of knowledge), seventeen
Pax (Roman goddess of peace), fourteen
Juno (Roman queen of the gods), thirteen
Vulcan (Roman god of fire and metalworking), eleven
Hercules (Roman hero), eight
Apollo (Greek god of truth and music, among other things), six
Erebus (Greek god of darkness), six
Eureka (as in, "Eureka, I found it"), six
Peace, six
Percival (after Percival Lowell, who predicted the existence of the new planet), five
Osiris (Egyptian god of the afterlife), five
Athena (Greek goddess of knowledge), five

This list of most popular names is dominated by ancient deities, following the tradition of planet naming. Of these, six are male and four are female. Many of the latter were suggested by the increasingly vocal female population, whose status in society was improving dramatically at the time. In a letter suggesting six possibilities (Athena, June, Psych, Circe, Cassandra and Atalanta) and signed, "Star-rover, She is not a Feminist," the author wrote, "For ages men have been the Lords of Creation. Now that women are striving for the top o' the world it would be regarded as a compliment to the sex to give the new planet a feminine name. It might encourage further exalted aspirations."

Another theme of the times, the pursuit of peace, is obvious by the multiple suggestions of Pax and Peace. Walter Niehoff, a student at Lafayette College in Easton, Pennsylvania, compellingly captured this sentiment in his letter to the observatory: "The centuries of the past have been stained with the blood of many dreadful wars. Now the world is experiencing a great change. We are in the beginning of an era that shall be known to our posterity as the beginning of the solution for perpetual world peace. The eyes of all men are now looking toward that goal with a hope as never before."

Some names referred to the technological advances of the time. For instance, William von Arx of Brooklyn liked Aero Nautis because Planet X had been worked on during the era of aeronautics. Florence Wolf of

Philadelphia wrote, "Why not give it a modern name? The other planets are mostly named for the ancient gods and were discovered in ancient time. As this is a modern discovery why not name it for the greatest force of the modern age, electricity?" Florence Howie of Houston offered Mazda to commemorate the fiftieth anniversary of Edison's invention of his "Mazda" lightbulb, while Dr. E.K. Collier of Bowie, Texas, suggested Percival-Lindbergh or Percival-Lind in honor of Percival Lowell and American hero Charles Lindbergh, who three years after his historic flight across the Atlantic still garnered headlines.

Literature, both ancient and modern, inspired some suggestions. Ralph Magoffin of New York City harkened back centuries with Vergilius, in honor of the 2000th anniversary, being celebrated in 1930, of the Roman poet Virgil. Of more contemporary times, T. Horan of Dalton, Georgia, proposed the awkward-to-pronounce Poictesme, from James Branch Cabell's then-popular book *Life of Manuel*.

Howard Carter's 1922 discovery of the tomb of King Tut was still in the mind of Josephine T. of Harbert, Michigan, when she suggested Shu, the Egyptian god of the atmosphere, "as recently found by Mr. Howard Carter in the annex of the Tutankhamen Tomb." Even Prohibition, begun in 1920 but winding down by 1930, made an appearance in the naming game. Philip Bowman of Annapolis, Maryland, suggested Bacchus, the Roman god of winemaking, as "typical of the age we live in."

Many of the names honored individuals, particularly Lowell. These include simply Lowell or Percival but also combinations such as Percilo, Perlo, Perlow (the first letters of his first and last name) and Percius (Percival and his country, the United States). Gale Dismukes of Juneau, Alaska, wanted to honor the discoverer of the new planet, Clyde Tombaugh, with the name Tom Boy. She included a poem:

"The Planet Speaks"

"Tom Boy" "Tom Boy"
Let it be my name
Surely Mr. Tombaugh
Beats in this game.

Playing "Hide and seek"
I often have thought
I, should like to be discovered
By one self-taught.

Let the joyous tidings
Ring the world around
"Tom Boy" "Tom Boy"
The latest Planet found.

One of the cutest ideas came from Karl Underhill of New Hampshire. He wrote, "If I had discovered the new trans-Neptunian planet I would name it Jean after my two year baby girl. I do not know the definition of the name Jean but it means everything to me." He ended his note by saying. "This letter is not a crank."

While many of these suggestions undoubtedly made for good reading, the Lowell staff ultimately chose Pluto. Putnam explained in a press statement the decision to go with a Roman god, in accordance with the other planets. He said, "There have been many suggestions which have been weighed and sifted and suitable ones were narrowed down to three—Minerva, Cronus, and Pluto." Minerva was the staff's first choice but was already used for an asteroid, so they decided on Pluto, "the god of the regions of darkness where X holds sway." Putnam pointed out that Pluto's two mythological brothers, Jupiter and Neptune, were already represented in the solar system. "Now one is found for him [Pluto] and he at last comes into his inheritance in the outermost regions of the Sun's domain." In addition, the first two letters of the name—P and L—are Percival Lowell's initials. They serve as the basis for Pluto's official scientific symbol, forever linking Lowell to the planet.

Eighty-five years after Pluto's discovery and naming, the New Horizons mission revealed myriad geological and topographical features on this icy world, inspiring a new era of Pluto naming. Perhaps the most compelling name describes the iconic heart-shaped region: Tombaugh Regio.

CHAPTER 5

COMPANION

Certainly the manner in which the stage is set for a discovery is normally accomplished with scientific imagination and discipline, as in Clyde Tombaugh's discovery of the planet Pluto.
—*Jim Christy*

Following Pluto's discovery, observations of it continued for a while at Lowell Observatory, chiefly by Earl Slipher and Carl Lampland. But the technology of the day severely limited what they could learn. Pluto was never more than a speck on the emulsion of the glass photographic plates used for imaging the sky in that era, and it was too faint for the detailed spectroscopic studies that could have revealed its surface composition or the presence of its atmosphere. Slipher observed Pluto by eye using Lowell Observatory's twenty-four-inch Clark refracting telescope, in the hopes of resolving its disk and determining its diameter, but even on nights of excellent seeing he was unable to make out a disk and concluded that Pluto could be no larger than half an arcsecond across, corresponding to an upper limit of seven thousand miles on its diameter. Lampland photographed Pluto through various color filters and was the first scientist to report its yellowish color, but he was unable to detect any patterns of variation in its brightness or color due to rotation. Lampland continued to record photographic plates of Pluto using the forty-two-inch reflecting telescope at Lowell Observatory until his death in 1951, and the resulting collection of glass plates eventually went on to play a role in navigating New

Horizons to its successful encounter with Pluto (as told in Chapter 8). But after 1951, the staff of Lowell Observatory does not appear to have done any further Pluto research for several decades, though investigations into the nature of the new planet were continued by others, and Flagstaff and Arizona continued to play a role in the science.

In the late 1940s, the subject attracted the interest of Gerard Kuiper, a pioneer of modern planetary science and later the founder of the Lunar and Planetary Laboratory and Department of Planetary Sciences at the University of Arizona in Tucson. Kuiper brought a variety of techniques to bear in his efforts to learn more about Pluto, including observing it by eye in 1950 with the largest telescope in the world at the time, the Palomar two-hundred-inch, in collaboration with Milton Humason. They used a device called a diskmeter that produced in the telescope observer's field of view a circle of light with adjustable size and brightness, enabling a side-by-side comparison with Pluto. Taking turns at the eyepiece, Kuiper and Humason both estimated Pluto's size to be about 0.23 arcseconds, corresponding to a 3,700-mile-wide diameter. This size was considerably larger than Pluto's true diameter of 1,477 miles (as later deduced), suggesting that their estimate may have been thrown off by the presence of its moon Charon, which they did not know about at the time. But it was an uncomfortably small size for a planet that had been thought to be nearly as massive as Earth, in order to account for its assumed gravitational perturbations on the orbits of the giant planets Uranus and Neptune. Pluto's density would have to be absurdly high to accommodate so much mass in such a small volume, leading to speculation that Pluto might actually be larger but have an unusually smooth and shiny surface, like a ball bearing, so that most of the observed light would be reflected from a small point at the center of its disk. Or it might be made of some sort of degenerate matter, like a white dwarf star. Kuiper did not like those ideas and argued that Pluto must be much less massive than had been thought and that it had a relatively bright, snowy surface, consistent with frozen volatile ices. This idea ultimately proved to be on the right track, though it took quite some time for the scientific community to abandon the idea of a much more massive Pluto. This was an especially unpalatable interpretation for Lowell Observatory staff, since it meant that Percival Lowell's famous predictions of a much more massive trans-Neptunian Planet X had been erroneous and that the discovery of Pluto near Lowell's predicted location was just due to luck.

Additional evidence for Pluto's small size came from attempts to observe stellar occultations. These events occur when an object passes

in front of a distant star as seen from Earth. The object's size can be determined by measuring how long it takes to cross the star (and thus block the starlight from view). A potential occultation event in 1965 was predicted to be observable from North America. Ian Halliday, Robert Hardie and John Priser observed from Dominion Observatory in British Columbia, McDonald Observatory in Texas and Kitt Peak in Arizona. But none of them saw any dimming of the starlight, meaning Pluto didn't quite pass in front of the star. Such apparent close approaches between two objects in which no occultation actually occurs are known as appulses. Astronomers using the sixty-one-inch telescope at the United States Naval Observatory's Flagstaff Station (NOFS) recorded photographic plates of the star and Pluto before and after the appulse. Otto Franz of NOFS measured the plates using a comparator machine at the facility. Those measurements indicated that Pluto had passed just 0.14 arcseconds from the star, setting a firm (95 percent confidence) upper limit of 4,225 miles for Pluto's diameter and solidly quashing ideas about a larger Pluto with just a bright reflective spot near the center of the disk. Soon after, Franz joined the staff at Lowell Observatory, but he did not pursue further Pluto studies there until much later.

Gerard Kuiper was also a pioneer in applying the new technology of photoelectric photometry to Pluto, using photomultiplier tubes to measure its brightness. This method provided much greater precision than photographic plates, and Kuiper's 1952 and 1953 observations showed tantalizing hints of temporal variability in Pluto's brightness. Robert Hardie and Merle Walker, experts in photoelectric photometry, did further observations in 1954 using the sixty-inch and one-hundred-inch telescopes on Mount Wilson in California. Their breakthrough came in 1955, when they were able to obtain a large block of time on Lowell Observatory's forty-two-inch reflector. Lowell staff were not using the telescope that season because its primary mirror was in dire need of re-aluminization. The mirror coating was in such terrible condition that Walker and Hardie estimated the performance of the telescope to be comparable to that of a thirty-inch telescope, but that was still sufficient for them to record accurate photoelectric photometry of Pluto on fifteen nights during March and April 1955. Their data showed a consistent pattern of dimming and brightening that repeated regularly every 6.390±0.003 Earth days, the first determination of Pluto's rotation rate. The persistent light curve also provided strong evidence that Pluto's surface was not hidden from view beneath a cloudy atmosphere and that it featured distinct darker and brighter regions.

In 1964, Hardie followed up the earlier work with further photoelectric photometry of Pluto at Vanderbilt University's twenty-four-inch telescope, enabling him to show that although the light curve still looked roughly the same in 1964 as it did in the mid-1950s, it had increased slightly in amplitude and Pluto had become slightly darker overall. He attributed these changes to seasonal evolution of Pluto's surface rather than the changing geometry that scientists now know to be responsible. By folding together the new data with the data from the 1950s, he was also able to refine Pluto's rotational period to 6.3867±0.0003 days.

Leif Andersson at the University of Arizona did further photoelectric photometry observations in the early 1970s. Combining his new data with Hardie's data enabled him to refine the rotation period to 6.38737±0.00019 days and also to constrain the orientation of Pluto's spin pole. He was the first to show that Pluto was probably tipped over on its side, with the gradual dimming from the 1950s through 1970s being explainable as simply a geometric effect, if Pluto's equatorial regions were darker than its poles and it was approaching equinox. Pluto's increasing light curve amplitude was also consistent with the changing viewing geometry.

Spectroscopic studies of the variations in the brightness of an object as a function of wavelength can provide valuable information about its composition. Many investigators attempted spectroscopy of Pluto over the years, with gradually improving results as the technology of astronomical spectrometers advanced. Visible wavelength spectra obtained in the early 1970s by University of Iowa professors John Fix and John Neff and their students were particularly influential. They showed increasing reflectance from blue through red wavelengths, consistent with Lampland's report of a yellowish color and typical for solar system bodies. But compositional interpretations of their spectra were diverse, spanning the range from rocky through metallic compositions. A spurious upturn in reflectance at near-ultraviolet wavelengths in one of the spectra even triggered wild speculation about possible Rayleigh scattering (the scattering of light off particles in the air; this is why Earth's sky is blue) in a thick neon atmosphere. In 1976, Dale Cruikshank, Carl Pilcher and David Morrison from the University of Hawaii extended the observations into infrared wavelengths using a series of infrared filters at the four-meter telescope at Kitt Peak. Many solar system materials have strong, diagnostic absorption bands in the infrared, and Cruikshank's team discovered strong infrared absorptions on Pluto that matched the absorptions of methane ice, consistent with the idea of a small, bright, icy Pluto. Chris Benner, Uwe Fink and Richard Cromwell at

the University of Arizona published a visible to near-infrared spectrum in 1978 that also showed methane absorption. They noted that methane gas and methane ice have similar absorptions and attributed the absorption to a thick atmosphere. It took several more years before spectra had improved to the point where it became clear that Pluto's methane absorption is almost entirely due to surface ice and that ices of nitrogen and carbon monoxide are also present on Pluto's surface. In the early 1980s, a series of spectra recorded by Marc Buie, then a student of Fink at the University of Arizona, showed that the methane absorption varied with the light curve as Pluto rotated, behavior that strongly favored the surface ice interpretation.

PLUTO HAS A FRIEND

Despite numerous observations following its discovery, Pluto's satellites evaded discovery for many decades. This was despite several dedicated satellite searches. For example, two such searches were done in 1950 by Gerard Kuiper using the McDonald eighty-two-inch reflecting telescope and by Milton Humason with the Palomar two-hundred-inch, both using photographic plates. Their efforts came up empty. When Pluto's largest satellite was finally discovered by Jim Christy in 1978 on plates taken at NOFS, it was not through a dedicated search but rather a serendipitous discovery on photographic plates made for purposes of routine astrometric monitoring to refine Pluto's orbit around the Sun.

Christy had ties in Flagstaff, having worked at NOFS. This facility was established in 1955 to serve as the Naval Observatory's dark-sky site for optical and near-infrared astronomy. Christy began working there in 1962, spending much of his time photographing and precisely measuring the positions of double stars while studying astronomy at the University of Arizona in Tucson. Occasionally for his research, he used Lowell Observatory's twenty-four-inch Clark refracting telescope. Christy earned his bachelor of science degree in astronomy in 1965 and continued working at NOFS until a transfer took him to the Naval Observatory's headquarters in Washington, D.C.

In the summer of 1978, he was splitting his time between moving into a new home and continuing a project he had started the previous year that involved measuring the position of Pluto in order to refine its orbit. To make these calculations, Christy requested astronomers at his

Jim Christy specialized in the study of binary stars but is most remembered in astronomy circles for his discovery of Charon. *Jim Christy.*

old stomping grounds in Flagstaff to take several images of Pluto using NOFS's sixty-one-inch telescope. Named the Kaj Strand Telescope, after a Danish astronomer who served as scientific director of NOFS from 1963 to 1977, this instrument saw first light in 1964 and is the largest telescope operated by the Naval Observatory. Located four miles west of Flagstaff, its iconic dome is a landmark to travelers along Interstate 40 near the community of Bellemont.

NOFS astronomer Anthony Hewitt took the requested Pluto images on April 13 and May 12, 1978, capturing them, like Clyde Tombaugh had in his discovery of Pluto nearly a half century earlier, on photographic glass plates. They were then sent to Christy in Washington, D.C., and on June 22, he began examining these and other Pluto plates from 1965, 1970 and 1971. Christy used a high-precision measuring machine called Starscan that projected an image—at thirty times magnification—onto a three-foot screen.

Many of the plates seemed to be of poor quality because Pluto appeared asymmetrical, with a bulge in the north–south orientation. What really got Christy scratching his head, however, was the fact that the background stars didn't exhibit the same lopsidedness. Elongation of all the bodies—Pluto

Jim Christy points to an image of his newly discovered moon. *Jim Christy*.

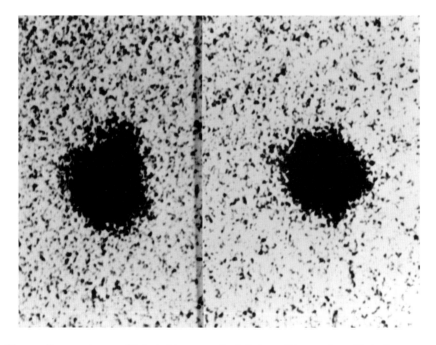

Charon discovery images. Distorted image on the left shows Charon above Pluto; image on the right is not distorted since Charon is in line with Pluto. *USNO*.

and the stars—would have been easily explained as defective images, but with only Pluto being distorted, the answer had to be something else.

In the foreword to the book *Out of the Darkness: The Planet Pluto* by Clyde Tombaugh and Patrick Moore, Christy wrote, "The elongation was fainter than the core of Pluto's image, which made it appear unlike any image caused by motion of Pluto in its orbit. I thought about the possibility of a flare of some sort being emitted by Pluto, but at the instant I realized that the 12 May elongation was north of Pluto and that the 13 April elongation was to the south, the concept—moon—jumped into my thoughts."

The next day, Christy detected the bulge on enough of the plates to determine that it migrated around Pluto over a period of 6.39 days. His colleague James Harrington made some orbital calculations that confirmed this observation. Thus, not only did Christy have a new moon, but he also knew its orbit.

As the person who discovered Pluto's companion, Christy had the honor of naming it. He initially favored Oz (from *The Wizard of Oz*) and Char-on (his wife's nickname plus "on" to make it an object, like "electron"), but these didn't hold with the convention of naming moons after mythological characters. However, in scanning through his dictionary late one night, he was astounded to see that Charon was a real name, the mythological boatman who ferried the souls of the dead across the River Styx to the underworld, which was the domain of Pluto. Christy had his name, one that followed appropriate scientific naming rules while honoring his wife. Charlene likes to joke, "Many husbands promise their wives the moon, but mine delivered."

Some of the coincidences with Charon's discovery are almost spooky: the discovery plates were taken just four miles from where Clyde Tombaugh discovered Pluto in 1930, and Christy made the actual discovery in Washington, D.C., only one hundred yards from where Asaph Hall discovered the two moons of Mars in 1877, the same year Italian astronomer Giovanni Schiaparelli first detected the supposed canals of Mars. This had inspired Percival Lowell to found his observatory in Flagstaff, where he commenced a planet search that culminated with Tombaugh's discovery.

Jim Christy eventually found his way back to Arizona, working for Hughes Missile Systems (now Raytheon) in Tucson for seventeen years. With his important ties to Pluto, it seems appropriate that, after retiring in 1998, he moved back to Flagstaff.

MUTUAL EVENTS

The discovery of Charon was a crucial breakthrough for the study of Pluto, because its orbit allowed the total mass of the system to be directly measured. That mass turned out to be far too small to have perturbed the orbit of Uranus in the way Percival Lowell had thought, a point that the Naval Observatory people relished needling their Lowell colleagues about. Curiously, this momentous discovery does not seem to have drawn Lowell staff back into Pluto research, despite its happening right next door in Flagstaff. The recollections of Lowell people were mainly of disappointment about the low mass from Charon's orbit definitively debunking Percival Lowell's Planet X calculations. (Going back to Pluto's discovery, many scientists doubted that it was actually Lowell's purported Planet X. In fact, Pluto is much too small to cause the perturbations in the orbit of Uranus that Lowell thought existed. In another intriguing part of this story, modern astronomy shows that those perturbations don't actually exist, and thus, Lowell's perturbing body, Planet X, doesn't exist. Pluto just happened to be located in the same position as Lowell's predicted planet.)

That Charon's orbital period matched Pluto's rotation period and that it also appeared to be orbiting in or near the plane of Pluto's equator argued that the system was tidally locked. This was the first example of a planet being locked to its satellite, with the same face of Pluto perpetually oriented toward Charon. At the time, it was not yet possible to tell whether Charon's spin was also locked to the orbital period so that it, too, could always present the same face toward Pluto. The expectation was that it must be so, since tidal evolution theory calls for smaller satellites to become locked much faster than their primary planet. The Earth-Moon system is an example in which the satellite is tidally locked but the larger planet is not. Pluto and Charon are much closer in size to each other than Earth and its moon and thus would have more similar time scales to become tidally locked.

Immediately after the discovery of Charon in 1978, Leif Andersson at the University of Arizona determined that Pluto and Charon would soon undergo mutual events. These occur when the two bodies alternate in casting shadows on each other and/or obstructing the view of each other as seen from Earth. Mutual events offered a wonderful scientific opportunity that Andersson sadly did not live to see, as he succumbed to lymphoma the next year at the age of thirty-five.

Mutual event schematic showing the dance between Pluto and Charon over the course of the mutual event season. The larger object is Pluto and the smaller one is Charon. The hatched area shows the shadow of one on the other. *Will Grundy.*

The prospect of imminent mutual events attracted many new people to Pluto science, and a newsletter called *Ninth Planet News* was organized by Ed Tedesco (at the Jet Propulsion Laboratory, JPL) and Marc Buie (then at University of Arizona) to help coordinate observational efforts. Andersson's initial predictions were for events starting in 1979 or 1980, but the first mutual events were finally detected in photometric observations in early 1985 by Tedesco, Bonnie Buratti, David Tholin and Rick Binzel. Numerous events were observed—including by Schelte "Bobby" Bus at Lowell—over the course of the mutual event season that ultimately ran from 1985 to 1990.

The scientific bounty from the mutual event season was incredibly rich. For instance, from the durations of the events, the diameters of Pluto and Charon were determined. Pluto's was constrained to be between 1,425 and 1,490 miles and Charon's to between 745 and 810 miles. The events showed that Pluto has a higher albedo than Charon, meaning that it reflects a greater fraction of the sunlight that illuminates it. Folding in separate estimates of the mass ratio between the two bodies enabled astronomers to compute their bulk densities. The result was in the 1.92 to 2.06 g cm^{-3} range for Pluto and 1.51 to 1.81 g cm^{-3} for Charon. These numbers implied that both bodies must have significant quantities of rocky material in their interiors. As Charon and its shadow swept across

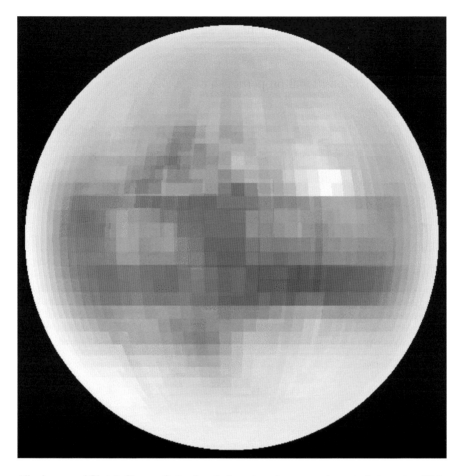

Albedo map of Pluto's Charon-facing hemisphere based on mutual event photometry. *Eliot Young.*

the face of Pluto over the course of each event, it progressively hid different regions from view. Combining data from numerous different mutual events enabled maps of Pluto's Charon-facing hemisphere to be constructed. This was done by several different teams led by Buie, Klaus Reinsch and Eliot Young. In addition to photometric monitoring, spectroscopic monitoring during mutual events enabled observers to distinguish surface compositions of the two bodies. Work by teams led by Michael DiSanti, Buie and Robert Marcialis revealed that the methane absorption was confined to Pluto, while Charon's surface was dominated by water ice.

Thanks to the discovery of Charon and the mutual event season that followed, in just a few years, Pluto and Charon went from a barely resolved binary speck of light to a new sort of double planet, with well-determined physical and compositional properties that were completely different from anything else known in the solar system.

CHAPTER 6

SHADOWS IN THE NIGHT

It took a long time to find Planet X and so it may take a lot more time and work in determining clearly its real nature.
—V.M. Slipher

From the 1950s through the 1980s, little or no Pluto research was done at Lowell Observatory. Staff focused on other topics, including the problem of light pollution from Flagstaff's city lights, an effort that led to the development of Lowell's Anderson Mesa dark sky site twelve miles southeast of Mars Hill. The space race was also in full swing, and the Soviet Union claimed one of the prominent early prizes with its 1957 launch of the first artificial Earth-orbiting satellite, Sputnik 1. Lowell Observatory opportunistically took advantage of the resulting flood of federal funding for space-related work. The staff expanded and did extensive observational studies of the Moon and brighter planets. They even assisted in training astronauts for the manned Moon missions.

In the 1970s, staff began getting involved with occultation research. As discussed earlier, an occultation occurs when two celestial bodies become aligned such that one of them blocks, or occults, the view of another. Why would scientists ever want their view of something to be blocked? The reason is that it can provide unique information, both for the object being occulted as well as for the foreground occulting body. For instance, as a star is occulted by Earth's moon, the star's light doesn't quite disappear instantly, thanks to the star's finite size. It instead fades out over a fraction of a second. Stellar

disks could not be resolved in conventional telescopic imaging, but the finite time of their fade-out or reappearance could be measured using high-speed photoelectric photometry, enabling measurement of stars' angular sizes and also revealing the binary nature of some.

Such an event can provide a comparably valuable probe of the occulting body, too. The size of an unresolved asteroid, for example, can be determined from the duration of time that it occults a background star. If such an occultation is observed from multiple locations on Earth, each location sees the star slice as a distinct "chord" across the asteroid. Multiple chords can be combined to get a silhouette that reveals the shape of the asteroid. For an occulting object with rings or an atmosphere, the background star's brightness can vary in a more complicated way, flickering on and off as it crosses narrow rings or fading gradually as its rays are increasingly refracted by a planetary atmosphere.

Effectively, what is being done is mapping out the shadow of the occulting object in the light from a distant star, cast onto the screen of Earth. If the occulting object is much larger than Earth, such as Jupiter or Saturn, then its shadow is also much larger than Earth. In that case, it doesn't matter too much where on Earth the observers are located, as long as they are on the night side of Earth and the object is above the horizon. They may as well use an existing observatory to observe the event. But for a small object like an asteroid, the shadow is equally small, which means the observer has to be in just the right place to see the event. Interest in these smaller targets motivated development of a series of portable occultation observing systems by Lowell staff. These systems enabled them to chase occultations all over Earth, resulting in many important scientific discoveries, as well as exciting adventures.

One of the earliest Lowell occultation expeditions involved former Lowell director Bob Millis, Ralph Nye and Nat White. Millis and Nye planned to observe an asteroid occultation from Grand Junction, Colorado, while White headed to Wyoming. Due to limited funding to support these early occultation studies—both for travel expenses and instrumentation needs—Millis and Nye had to first drive White up to Wyoming and drop him off, then head down to Colorado and observe the occultation with cobbled-together instruments. They then drove back to Wyoming to pick up White before finally heading home to Arizona. Besides this outrageous itinerary, Millis and Nye had to weather bitterly cold temperatures, as well as a brush with the law. While in Colorado, these two intrepid explorers were pulled over by a policeman who suspected they were running guns for an armory.

Such episodes made for a rocky beginning to the Lowell occultation program, but the astronomers persevered in this otherwise productive effort. They determined the sizes of numerous asteroids and studied the atmospheres of several planets. They also observed mutual occultations of one satellite of Jupiter by another. Similarly, they investigated outer solar system satellites via stellar and lunar occultations.

Lowell staff involved with this early occultation work at Lowell included Millis, White and Nye, as well as Bill Baum, Larry Wasserman, Otto Franz, Rich Oliver and Ted Bowell. They often worked in collaboration with Massachusetts Institute of Technology (MIT) scientists Ted Dunham (who eventually moved to Lowell in 1997) and Jim Elliot.

The occultation program took a major step forward in 1977 with an important discovery pertaining to Uranus. Astronomers had predicted that on March 10 of that year, the planet would pass in front of the ninth-magnitude star known as SAO 158687. They hoped to accurately measure the diameter of Uranus, but this required gathering two chords across the planet. A group of scientists from Cornell University, including Elliot and Dunham (who both worked at Cornell at the time), gathered one of the chords aboard the Kuiper Airborne Observatory (KAO), a Lockheed C-141A Starlifter jet transport aircraft modified to carry a thirty-six-inch telescope. Cruising at altitudes of some forty-one thousand feet, this flying observatory allowed astronomers to observe at infrared wavelengths, a part of the electromagnetic spectrum not typically visible from ground-based observatories.

While the KAO flew over the Indian Ocean, a second team, including Lowell's Millis, operated a twenty-four-inch telescope—bought by Lowell in the 1960s for a worldwide planet-observing program called the International Planetary Patrol—at the Perth Observatory in Australia. About half an hour before Uranus was expected to move in front of the star, the starlight suddenly and unexpectedly dimmed. This lasted for only a few seconds before brightening again. A few minutes later, this cycle of dimming and brightening repeated; it would happen five times in all before Uranus finally blocked the starlight. After the event ended, the five-stage sequence recurred. The astronomers soon realized that the dramatic dips in brightness were the result of a series of five rings around Uranus.

These successful Uranus observations inspired staff to upgrade their observing equipment. With grant funding, they purchased three Celestron telescopes and developed customized photometers (instruments that measure the intensity of light) to use with them.

The Kuiper Airborne Observatory sits next to its larger successor, SOFIA. *NASA.*

Even though this system allowed the astronomers to go anywhere in the world to observe an event, they followed a basic rule of thumb in planning excursions. Larry Wasserman said in a 2017 interview, "We don't go anywhere where we're unlikely to come back from. Events that occur over areas like Syria or Iraq or Iran are generally put in the category of 'We aren't going there.'" Wasserman added that this rationale is not always foolproof. He told of a French astronomer, Bruno Sicardy, who once went on an occultation expedition that seemed in a safe area. He was set upon by banditos, who stole his wallet and tied him to a tree, where he was stuck for hours.

OCCULTATION ADVENTURES

While Lowell astronomers didn't experience such dire conditions on observation runs, they nonetheless endured many unexpected escapades not typically associated with astronomical research. Wasserman and Nye once journeyed to Texas, near the Mexican border, and set up their equipment

off a remote dirt road. When the occultation ended up not happening, the team packed up their equipment under the light of a one-hundred-watt bulb. As they finished, they noticed a blue and red light several miles off that seemed to turn in their direction. The light moved their way and proved to be authorities, who stopped them thinking they were drug runners. The exact conversation has been forgotten, but the vision of these virtuous scientists being suspected of anything having to do with drugs is humorous to anyone who knows them.

Wasserman once traveled to the Central Pacific Ocean to observe an occultation on the diminutive island Nauru, which covers all of eight square miles. It was serviced by a single airline, with only one flight leaving the island each week. Wasserman was required to take out an insurance policy to travel there—evacuation insurance. The reason was simple: in the event of an emergency that would require him to be evacuated from the island, the special transport that would have to be flown in cost $100,000. Not only that, but the island didn't have banks and all services had to be paid with cash. This meant that Wasserman, who normally didn't carry more than $10 or so at a time, had to stuff his wallet with $3,000 in Australian money so he could buy food and pay for accommodations.

Perhaps the most notorious adventure involved a "heroic truck-borne occultation chase into Mexico," as Bob Millis called it in a 2017 interview. Millis, Nye and Wasserman were part of a group that observed an occultation by the dwarf planet (then classified as an asteroid) Ceres. Wasserman and Nye formed one observing team and drove from Flagstaff to the base of operations in Mazatlan. They planned to enter Mexico at Nogales, and all the appropriate arrangements were made for this, but when they arrived at the border, nobody there had any documents related to their work. Officials whisked them to a holding area, reminiscent of an old western jail with bars. This was clearly used for holding smugglers; lining the nearby parking lot were cars that had been ripped apart by officials looking for contraband.

Wasserman and Nye explained that they were scientists and had to be at a certain place at a certain time, but they were still detained for five hours. Darkness had set in by the time they were released. In order to get to their observing location in time for the occultation, they had to drive throughout the night. They were alarmed to pass several vehicles whose lights were turned off and felt more comfortable when daylight arrived. This meant they could now better see the oncoming traffic, but this in itself could also be unnerving. At one point, they noticed a school bus heading in their direction—sideways. The front and back wheels were apparently so out of

Larry Wasserman, Ralph Nye and Bob Millis prepare for an occultation expedition in the 1980s. *Ralph Nye.*

Marc Buie sets up a Celestron 14 telescope in Chile for a July 2002 Pluto occultation. *O. Saa.*

The day before the flyby, New Horizons principal investigator Alan Stern distributes U.S. flags for celebratory moments. *NASA/JHUAPL/SwRI/H.B. Throop.*

Jim Christy holds his dictionary while wife Charlene points to the entry for "Charon." *Kevin Schindler.*

Work stations on board the Stratospheric Observatory for Infrared Astronomy (SOFIA). *Kevin Schindler.*

Science instruments attached to Nasmyth focus of SOFIA. *Kevin Schindler.*

The 1991 U.S. first exploration postage stamp series. The lower right stamp shows "Pluto not yet explored." *U.S. Postal Service, photo by Will Grundy*.

NASA's New Horizons mission logo is nine-sided, appropriate for the ninth planet to be explored by a NASA spacecraft. *NASA*.

Artist's impression of the New Horizons spacecraft. *NASA/JHUAPL/SwRI*.

Launch of New Horizons aboard a Lockheed Martin Atlas V launch vehicle, January 19, 2006. *NASA/JHUAPL/SwRI*.

MIT alumni gather at the New Horizons flyby event. *Kevin Schindler.*

Percival Lowell's great-grandnephew, W. Lowell Putnam, stands with Clyde Tombaugh's daughter, Annette, at the New Horizons flyby event. *Kevin Schindler.*

W. Lowell Putnam with several New Horizons team members with Lowell Observatory ties. *Left to right*: Putnam, Marc Buie, Simon Porter, Cathy Olkin and Will Grundy. *Kevin Schindler*.

A live NASA TV broadcast with New Horizons team members. *Seated, left to right*: Alan Stern, Hal Weaver, Will Grundy, Cathy Olkin and John Spencer. *Kevin Schindler*.

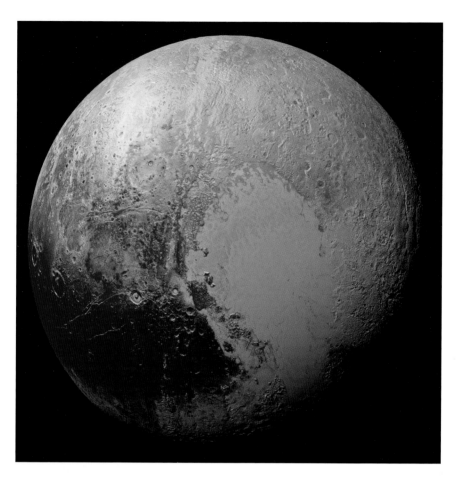

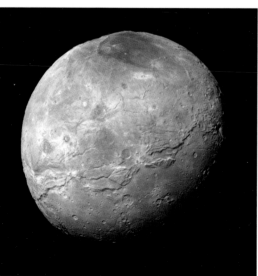

Above: New Horizons MVIC-enhanced color view of Pluto, with MVIC's 400–550, 540–700 and 780–975 nm filters displayed in blue, green and red color channels, respectively. *NASA/JHUAPL/SwRI*.

Left: MVIC-enhanced color view of Charon, with same filters as previous image. *NASA/JHUAPL/SwRI*.

Science team and Public Affairs Office (PAO) team in the PAO room reacting to new data, accidentally revealing phone numbers on the white board in the background. *NASA/ JHUAPL/SwRI.*

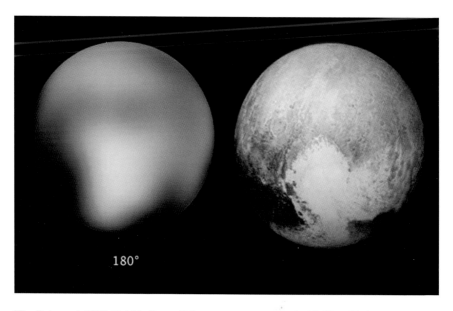

180°

The Buie et al. 2010 Hubble Space Telescope map compared with New Horizons' view of the same hemisphere. *NASA/ESA/M.W. Buie; NASA/JHU-APL/SwRI.*

The Buie et al. 2010 Hubble Space Telescope map rendered as seen from various longitudes. *NASA/ESA/M.W. Buie; W.M. Grundy.*

Will Grundy open-mouthed in astonishment at new data. In actuality, the picture was taken during a lively debate on arcana of planetary photometry, but it perfectly told the story of discovery. *NASA/JHUAPL/ SwRI/M. Soluri.*

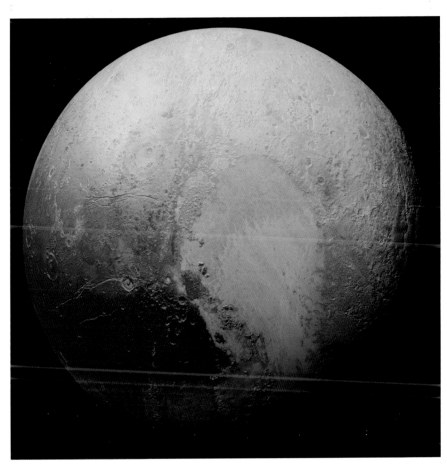

Pluto looks psychedelic in an image created using principle component analysis to highlight color contrasts across the planet's face. *NASA/JHUAPL/SwRI/W.M. Grundy.*

The full "wow!" image taken shortly after closest approach, showing a crescent Pluto surrounded by a diffuse glow of atmospheric haze. *NASA/JHUAPL/SwRI.*

High-resolution color departure image showing the blue coloration and numerous discrete layers of Pluto's atmospheric haze. *NASA/JHUAPL/SwRI.*

Stephen P. Maran, COMP team's embedded science writer, holding up the July 16, 2015 *New York Times*. New Horizons dominates the front page, with the Iran nuclear deal confined to a narrow strip at right. *NASA/JHUAPL/SwRI/H. Throop.*

On the evening of July 14, 2015, Alan Stern and Will Grundy hoist a hacked version of the 1991 postage stamp. *Elliot Severn/AmericaSpace.*

Lowell Observatory educators gather around the Pluto discovery telescope and give the "Pluto Salute." *Lowell Observatory.*

Annette Tombaugh samples a Pluto Roll at Karma Sushi Bar Grill in Flagstaff. *Kevin Schindler.*

Pluto and New Horizons postage stamps issued in 2016. *U.S. Postal Service.*

Left: Ceramic artist Paula Rice created this figurative representation of Pluto in 2009 as part of her Planet Series. *Kevin Schindler.*

Right: Paula Rice's *The New Pluto*, which she completed after the New Horizons flyby of Pluto in 2015. *Tom Alexander.*

Clyde Tombaugh's career-defining work at Lowell Observatory and other highlights of his life are depicted on this memorial window at the Unitarian Universalist Church of Las Cruces, New Mexico. *Kevin Schindler.*

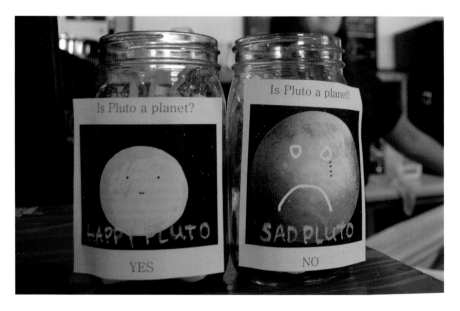

In 2015, customers to Late for the Train coffeehouse in downtown Flagstaff could vote on Pluto's planetary status while ordering Pluto coffee. *Sarah Gilbert.*

alignment that the vehicle maintained a cockeyed orientation. Later, they stopped for gas and were further disconcerted to see men with guns hanging around the pumps.

The tired pair finally reached their base of operations at a hotel in Mazatlan. From there, they headed sixty miles south, where they set up their observing equipment along an unpaved road overgrown with grass. Their luck seemed to finally change as they successfully observed the occultation. By 1:00 a.m., they had repacked their equipment, ready to return to the hotel. But alas, as Nye turned the key to start the car, nothing happened. This was in the pre-cellphone era, so they couldn't call for help. Wasserman recalled, "So here we were, in the middle of nowhere, sixty miles south of our hotel. It's one o'clock in the morning and there's really nothing we could do, so we curled up on the seats in the cars and went to sleep."

The next morning, Wasserman and Nye walked about a mile down the road to a highway. Nye didn't speak any Spanish, so Wasserman was the designated Spanish speaker. In telling the story, he laughed, "I last spoke Spanish with Miss Garcia in eleventh grade." He was able to communicate the basic car problems, and the truck driver agreed to give them a ride so they could get help. They were startled when he pulled out a menacingly large stick. To their relief, the driver had no nefarious intent; he went around the truck and whacked each tire with the stick, apparently checking the soundness of each.

The driver took Wasserman and Nye to a town, where they caught a cab back to Mazatlan. They had to be careful where they put their feet because the floorboard was punctured, revealing the road beneath them. They also had to keep their eyes open because the driver began going in the direction opposite of Mazatlan. It turned out he just wanted to show them some sort of construction project in the area. They finally got back to their hotel and headed to the restaurant for a long-overdue meal. Meanwhile, Millis and his observing partner had returned to the hotel from their occultation station. Their location was much farther away than that of Wasserman and Nye, so they were surprised to find they weren't in their rooms. Millis guessed they simply hadn't yet returned and finally went to the hotel desk to see if Wasserman and Nye had left any message. The desk clerk gave him a note written by Wasserman the previous day that said they had gone observing and if Millis was reading the note, it probably meant they were in trouble. Millis, alarmed, raced out the door to search for his colleagues. The astronomers soon found one another and enjoyed a good laugh; decades later, they were still laughing about this wacky trip to Mexico.

ATMOSPHERE AND SNIKES

It was Lowell staff's opportunistic pursuit of occultations that finally brought the observatory back into the business of studying Pluto, when a stellar occultation visible from Australia and New Zealand was predicted for 1988. This provided a key breakthrough in Pluto studies, proving the existence of Pluto's atmosphere and revealing its thermal structure. It was Lowell Observatory's first step back into Pluto research since the early 1950s, work that has continued at Lowell ever since. But it was not the first use of stellar occultations to investigate Pluto. Chapter 5 described the 1965 appulse (a near-miss occultation) that proved Pluto to be small and bright. A single-chord 1980 stellar occultation of Charon observed from South Africa by Alistair Walker set a lower limit on Charon's diameter of 745 miles, as well as putting tight limits on any presumed atmosphere of Charon.

The first occultation detection of Pluto's atmosphere was through a grazing occultation observed from Israel by Noah Brosch in 1985. Unfortunately, that observation was done during challenging conditions: not far above the horizon, through scattered clouds and with Israeli jet fighters flying training exercises and dropping flares. The results were not published until ten years later, well after the 1988 event, making them less influential than they otherwise could have been.

For the 1988 event, observing teams based their predicted path positions on data recorded on photographic glass plates of the sky produced with the Naval Observatory's sixty-one-inch telescope. The path went over eastern Australia, New Zealand and into the Pacific Ocean. Astronomers from many institutions tried to get as close to the center of the path (center line) as practical.

One group, with future Lowell astronomers Dunham and Amanda Bosh, as well as Elliot, studied the event aboard the KAO. This observation almost didn't happen due to extremely hot conditions in Hawaii. The flight left from Hickam Air Force Base at Honolulu, and because it was going to be so long, technicians fueled the plane to its maximum capacity. The fuel expanded in the heat and overflowed through runoff valves. Dunham remembered, "Somebody who was operating the airplane by the book would have scrubbed the flight. But an Air Force guy came over and hosed it down, and we were able to fly. We came that close to not being able to go."

On the ground, some groups observed from well-placed, fixed observatories, while others used portable systems. Millis and Nye drove to northeastern Australia, about thirty minutes outside of Charters Towers,

The 1988 Pluto occultation shadow path cuts across Australia and New Zealand. *Larry Wasserman.*

where they used one of the Celestron systems. They felt good about this location, as they had an open horizon and the skies were clear. With kangaroos hopping about, they set up and tested the equipment and then just needed to keep an eye on it until the event happened the following evening. It was during that waiting period that their resolve was tested by flies. They swarmed the astronomers, flying into their noses and eyes and mouths and driving them to distraction. Millis recalled the day:

> *The main thing I remember, in fact I have a clearer memory of this than any of the science, was on that day we were babysitting the equipment. It was a hot afternoon, lots of flies, and here comes this beat-up, battered pickup truck through the bush. It drives up to us, and this guy gets out. He was a little guy, interesting person. In mixed company I can't simulate the conversation. But he packed more profanities in a single sentence than anybody I ever encountered before. So we got talking about the flies, and he was telling us how you deal with the flies. He said you learn to talk without moving your teeth. Then he started telling us about the "snikes" that chase you.*

Despite these challenges, Millis and Nye persevered and obtained useful data the following evening, keeping an eye toward the ground for the menacing snakes. Their observations, coupled with those of the other teams, revealed that the occulted star's light dimmed gradually, as expected if an atmosphere was present, but then abruptly dipped. They interpreted this as a global haze layer.

MODERN OCCULTATION STUDIES

Pluto occultation studies have continued at Lowell through the present day, involving numerous additional staff members over the years, including Marc Buie, Amanda Bosh and Stephen Levine. NASA's much more capable replacement for the KAO was the Stratospheric Observatory for Infrared Astronomy (SOFIA), a converted Boeing 747 jetliner fitted with a one-hundred-inch telescope, much larger than the KAO's thirty-six-inch version.

On June 29, 2015, Lowell's Ted Dunham, Tom Bida and Peter Collins flew aboard SOFIA while Stephen Levine and Larry Wasserman joined ground-based teams, all with the same goals of observing a stellar occultation by Pluto. The scientists were especially interested in learning more about Pluto's atmosphere. Bosh led another group, squirreled away in an office at Lowell, which provided last-minute course corrections for SOFIA. These were critical to the successful observation of the event. This event happened just two weeks before the New Horizons spacecraft flew by Pluto, allowing astronomers to compare essentially simultaneous data gathered from two different sources.

As with the 1988 occultation, astronomers planning to observe this event from the air almost missed it. This time, the team prepared to fly out of New Zealand. In preparing the airplane for the mission, workers needed to load supplies and so positioned a lift truck next to the main door. This was in June, wintertime in New Zealand. A storm blew in and winds picked up, pushing the truck against the plane with a repeated "Bang! Bang! Bang!" The workers moved the truck, but not before it had dented the plane's fuselage. Air New Zealand technicians measured the depth of the dent to see if the fuselage had to be replaced. Fortunately, it didn't; if the gash had been a little deeper, the repair would have taken a couple of days and the occultation would have been missed.

Lowell's Ted Dunham and Peter Collins look at a computer screen while flying aboard SOFIA. *Ted Dunham*.

Past and present Lowell staff who have participated in Pluto occultation events, posing in front of the Pluto discovery telescope in 2015. *Kevin Schindler*.

This event served as sort of a last hurrah for Pluto occultations, since Pluto is moving toward an area of sky with far fewer background stars available to be occulted. But other relevant studies were still happening. In 2017, Wasserman traveled to southern Argentina to observe an occultation of the distant icy body known as 2014 MU69, the follow-up target for the New Horizons spacecraft after it flew by Pluto. The main goal was to identify the true brightness of the object so that during the 2019 flyby, scientists could take proper exposures; it would be quite a shame for New Horizons to capture images, only to find out that they came out too dark or bright.

Wasserman wasn't alone on his journey; he was part of a team that set up telescopes along a path over which the shadow of 2014 MU69 was expected to pass. The event itself would last just one second! Wasserman estimates that occultation observations are successful only about half the time. To maximize the likelihood of successfully seeing this one, a large contingency of observers was deployed, with fifty scientists participating. They paired off and set up a total of twenty-five telescopes, spread out every couple of miles along the path. The astronomers realized not every telescope would see the event, but even if just five did, the effort would be deemed a success.

The logistics of this observation, overseen by former Lowell astronomer Marc Buie (now at the Southwest Research Institute in Boulder), were mind-boggling. The telescopes and associated equipment had been used to observe an earlier 2014 MU69 occultation and then stored. The space needed for this was not trivial: each of the twenty-five units filled four packing crates, each measuring about three to four feet wide, three feet high and two to three feet deep. As the event approached, each telescope operating team picked up its equipment with a rented truck—a total of twenty-five trucks for one hundred crates—and drove to its respective observing site.

The observers experienced many issues—strong winds, heavy traffic along a road near the telescopes and technical glitches with some of the telescopes. Yet the scientists overcame most of these problems with the help of unexpected sources. Police closed the road for two hours and local truck drivers parked eighteen-wheelers upwind of several of the telescopes in order to block the wind. Other support came from NASA, the U.S. Embassy, the Argentinian Space Agency and the Argentinian Air Force. Even the Argentinian Coast Guard helped out, supplying a helicopter that could be used in the event of an emergency. Wasserman was pleased and surprised by this support. On most excursions such as this, the scientists don't interact with the public or local government.

Five of the teams observed the event, and by all accounts, it was a successful mission. Results of the observations indicated a fascinating twist to the very nature of 2014 MU69: while it might be an oddly shaped single object, it also may be a binary body (two bodies orbiting each other).

SETTING THE STAGE
FOR A MISSION

The real voyage of discovery consists not in seeking new landscapes,
but in having new eyes.
—Marcel Proust

The angular resolution of a telescope is limited by the diffraction of light, an inescapable physical principle. For a given wavelength, the bigger the telescope aperture, the finer the detail it can resolve. But turbulent motion in Earth's atmosphere produces additional blurring that limits the practical resolution of ground-based telescopes to far worse than their theoretical diffraction limit. Astronomers use the word "seeing" to describe this blurring. Under good seeing conditions, this blurring might be around one second of arc, the size of a United States quarter as seen from a distance of three miles. Details any smaller than that would be impossible to make out. Under truly exceptional conditions, seeing might be as good as a half or even a quarter of an arcsecond. The seeing resolution limit was an especially frustrating impediment for scientists studying Pluto, since as seen from Earth, its separation from Charon is never more than about one arcsecond, and the disk of Pluto is only about a tenth of an arcsecond across.

The Pluto-Charon mutual event season of the 1980s was scientifically valuable because prior to that time, astronomical telescopes had struggled to even resolve the two bodies from each other, and resolving the disk of Pluto was barely even imaginable. The mutual events had enabled observers to

Hubble Space Telescope after the fourth servicing mission in 2002. *NASA*.

cleanly separate the light from Pluto and Charon and even to resolve albedo features on their disks.

But scientific studies of Pluto have always benefited from technological progress, and the astronomical community was not standing still. It was hard at work trying to overcome the seeing problem. A telescope located above Earth's atmosphere should be able to achieve diffraction-limited imaging, and NASA was investing considerable resources into bringing such a system to life during the 1970s and 1980s. A great many technological hurdles had to be overcome, leading to considerable schedule delays and cost overruns, but the Hubble Space Telescope was finally launched into orbit aboard the space shuttle Discovery in 1990. Hubble's ninety-four-inch mirror offered the prospect of 0.05 arcsec resolution for visible wavelength imaging.

HUBBLE SPACE TELESCOPE

Marc Buie was eager to take advantage of Hubble's capabilities for Pluto studies. To pursue this, he took a position at the Space Telescope

Science Institute in Baltimore in 1988. Using Hubble would prove to be a significant challenge for two main reasons. First, the primary mirror had been mistakenly shaped to the wrong prescription, resulting in severe spherical aberration. Before corrective optics were installed by astronauts during the first shuttle servicing mission to Hubble in 1993, scientists had to make do with aberrated images and were forced to become proficient in image deconvolution. Second, the telescope's attitude control systems were not designed with moving object tracking in mind. Pluto moves across the sky quite slowly for a solar system object, at just a few arcseconds per hour relative to the background stars, thanks to its great distance. But with the exquisite resolution of Hubble, appreciable trailing would be obvious within a minute if the telescope was held in a fixed position as for normal astronomical targets. Buie had to work with the engineers to develop new procedures. As a result of those efforts, Hubble was able to contribute to Pluto studies in many ways. In 1991, Buie moved to Lowell Observatory, where he continued to focus on using Hubble to study the Pluto system, in addition to making extensive use of Lowell's ground-based telescopes. Buie's first Pluto project with Hubble used the aberrated images to get separate light curves of Pluto and Charon, providing the first evidence that Charon's rotation was also tidally locked.

The ability of Hubble to resolve the disk of Pluto (albeit only barely) opened the opportunity for a new generation of maps not restricted to the Charon-facing hemisphere, as the mutual event maps had been. Following the installation of corrective optics in the 1993 servicing mission, Alan Stern, Buie and Larry Trafton proposed a plan to do this, resulting in a set of four observations during 1994. Each observation targeted a different central longitude on Pluto, spaced ninety degrees apart. Buie processed the ensemble of images into low-resolution global maps of Pluto's albedo features, showing striking albedo contrasts across the planet's surface. The fourth servicing mission in 2002 installed the much more capable Advanced Camera for Surveys. Using it, Buie and Will Grundy led a new, much more comprehensive campaign of twelve observations, evenly spaced in longitude. These were processed into a new, more detailed set of albedo maps.

Hubble's contribution to Pluto science was not limited to imaging. For instance, Cathy Olkin, then a postdoc at Lowell, used Hubble's fine guidance sensors to accurately measure the motions of Pluto and Charon around their common center of mass, or barycenter, working with Lowell astronomers Larry Wasserman and Otto Franz. From their observations, they were able

to compute the Pluto-Charon mass ratio, which in combination with the sizes from the mutual events led to refinements in the bulk densities.

Hubble also offered spectroscopic capability, and the 1997 servicing mission extended that capability into infrared wavelengths with the installation of the Near Infrared Camera and Multi-Object Spectrometer (NICMOS). Buie and Grundy observed Pluto and Charon with NICMOS, obtaining separate spectra during 1998 at four longitudinal phases as Pluto and Charon rotated around each other. The well-separated spectra of the two bodies revealed no sign of methane on Charon's surface at any longitude and showed that its water ice was mostly crystalline, rather than the amorphous ice that many had expected. There was also an indication of ammonia ice, a conclusion also reached using similar Hubble observations at different longitudes by a team led by Christophe Dumas, a Lowell postdoc who worked with John Spencer.

MORE EQUIPMENT

Although it made many important discoveries, Hubble was not the only telescope to advance Pluto science. Efforts to improve image quality from ground-based telescopes were also bearing fruit. There was a growing recognition that outside of the telescope dome, seeing can be considerably better than it is inside. Much of this "dome seeing" could be blamed on daytime warming of the building, telescope mount and especially the massive glass telescope mirrors. These components shed their daytime heat at night, producing local turbulent mixing analogous to that seen above a candle flame or campfire, degrading image quality. Observatories began to invest in thermal control, installing fans to circulate air to cool down more quickly at night. Many installed air conditioning systems to regulate the daytime temperatures inside their domes to match anticipated nighttime temperatures. People building new observatories put more effort into site testing prior to construction, as well as designing thermal control into their systems from the start. New, thinner telescope mirrors helped with this, as their temperatures could change to match the surrounding air much more quickly than the massive mirrors that were used in earlier telescopes. Benefiting from these sorts of seeing improvements implemented at the ten-meter Keck Telescope, Michael Brown and Wendy Calvin obtained separate spectra of Pluto and Charon in natural seeing in 1999, detecting

the same ammonia and crystalline water ice spectral features on Charon that Hubble's NICMOS observed. This was made possible by Keck's adaptive optics system, which exploits a powerful technique to correct the blurring effect of the atmosphere. It was originally developed for military purposes but was adapted for astronomical use in the 1990s, and it is now widely used to enable ground-based telescopes to achieve diffraction-limited imaging.

The astronomical spectrometer was another tool in which technological progress led to a series of key discoveries about the surface compositions of Pluto and Charon. Initially, spectrometers used photographic plates to record spectra, resulting in low sensitivity and limited wavelength coverage. Electronic detectors such as photomultiplier tubes offered greater sensitivity and precision, but typically just a single detector would have to be stepped through the wavelengths of interest, meaning that only a narrow wavelength band was being recorded at any one time. This is terribly inefficient and also prone to systematic errors when attempted during variable sky conditions. Novel infrared detectors developed during the 1970s and 1980s enabled spectroscopic observations in the infrared and were used to obtain improved spectra of Pluto and other icy, outer solar system objects. Initially, these were single detectors, analogous to single photomultiplier tubes, with filters used to select wavelengths sequentially. Circularly variable filters provided a convenient way of cycling through a series of wavelengths to produce a spectrum.

Arrays of detectors enable spectrometers to record light from multiple different wavelengths at the same time. CCD (Charge-Coupled Device) arrays fabricated from silicon were sensitive to visible light, and spectrometers based on them began to appear in the 1980s. Uwe Fink at the University of Arizona built one that both Buie and Grundy used in their thesis work. Infrared-sensitive arrays based on more exotic semiconductors such as indium antimonide and mercury cadmium telluride began to be used in astronomical spectrometers in the late 1980s and early 1990s. For best results, the entire spectrometer had to be cryogenically cooled to minimize background thermal emission from the optics and other components. Toby Owen and colleagues observed Pluto in 1992 using a spectrometer called CGS4 (CGS stands for Cooled Grating Spectrometer) at the 3.8-meter United Kingdom Infrared Telescope on Mauna Kea, discovering subtle absorption features of nitrogen and carbon monoxide ices.

When Lowell Observatory installed the Perkins Telescope at Anderson Mesa in 1961, it entered into a partnership with Ohio State University. OSU was focused on astronomical instrument development and used the

Perkins as a test platform. A new OSU cryogenic infrared spectrometer called the Ohio State Infra-Red Imager/Spectrometer (OSIRIS) arrived at the Perkins in 1995, and Buie immediately began observing Pluto with it. The prospect of using such an instrument to observe Pluto spectroscopically over time attracted Grundy to Lowell Observatory in early 1997. He and Buie observed Pluto intensively in 1997 and 1998, amassing spectra on eighty-three nights before OSU moved OSIRIS to another telescope. This huge data set enabled them to show that absorptions of Pluto's various ices (nitrogen, carbon monoxide and methane) all varied regularly as Pluto rotated, with the nitrogen and carbon monoxide absorption being strongest on the anti-Charon hemisphere, right where the HST maps had shown a large, bright spot. New Horizons would eventually map this area as Tombaugh Regio, Pluto's iconic heart-shaped region. From their telescopic observations, Grundy and Buie could not discern the exact nature of this feature, but it was clearly something unusual and interesting; when the New Horizons encounter sequence was planned in detail during 2008–9, the team made sure to time the flyby so that this curious "CO spot" would be oriented toward the spacecraft at the time of closest approach, enabling it to be imaged with good spatial resolution. The departure of OSIRIS interrupted their infrared spectral monitoring, but from 2000 onward, Grundy and Buie were able to continue monitoring Pluto using another new cryogenic infrared spectrometer called the Spectral Polarimeter for Planetary Explorations (SpeX) at the NASA three-meter IRTF (Infrared Telescope Facility) on Mauna Kea.

ROBOTIC SPACECRAFT

Planetary scientists have learned many things about the solar system using telescopes, but the ultimate technology-driven scientific advances have come from exploration by robotic spacecraft. Soviet Luna missions first explored the Moon in the late 1950s and 1960s. The United States, motivated by cold war rivalry, quickly ramped up its own program, sending the first successful missions to explore Mars in the 1960s, as part of the Mariner program. Many more robotic missions of exploration followed, and one by one, the Sun's planets were revealed as spectacularly complex worlds, each shaped by a rich interplay of processes enabled by their distinct orbital and thermal settings along with their distinct palettes of available materials. Each planetary

system was found to have experienced a unique history of events that left telltale traces in its chemistry, geology and dynamics. A vibrant community of planetary scientists has been learning to interpret these signatures.

Interest at NASA in sending a spacecraft to Pluto dates back to at least the mid-1960s, when a "Grand Tour" of the outer solar system was first envisioned. That concept eventually evolved into the spectacularly successful Voyager mission, consisting of two probes launched in 1977. Voyager 1 explored the Jupiter and Saturn systems. Its trajectory was designed to include an option to then go on to visit Pluto, but NASA opted instead for a close flyby of Saturn's largest moon, Titan. Voyager 2 visited all four giant planets, reaching Neptune in August 1989, but its trajectory precluded a Pluto visit. Voyager 2 images of Neptune's largest moon, Triton, revealed a youthful surface with spectacularly enigmatic geology, including many features not seen previously on any other planetary body. Since Triton and Pluto are similar in size and share many of the same cryogenic ices on their surfaces, there was every reason to believe that Pluto should hold a comparable scientific bonanza. Pressure for a mission continued to build in the scientific community.

NASA studied a variety of Pluto mission options through the 1990s and into the early 2000s but struggled to get the pieces to line up. The agency lurched between pursuing large, expensive scenarios that proved to be unaffordable and "faster, better, cheaper" schemes that never seemed to reach fruition. The result was a frustrating decade of studies, planning efforts, high hopes and cancellations.

During that time, pressure within the scientific community ratcheted up. Starting in 1989, when he was still a graduate student, Alan Stern played a key role in agitating for a Pluto mission, organizing interested scientists and cultivating public support. Flagstaff people were closely involved in this movement. One of the formative early steps many of them point to was a December 1989 dinner meeting following the Pluto session at the American Geophysical Union meeting in Baltimore. Dubbing themselves the "Pluto Underground," the attendees dedicated themselves to pushing for a NASA mission. Many of them subsequently served on various NASA and National Research Council advisory bodies, where they kept reiterating the case for a mission. For instance, Stern chaired a group called OPSWG (Outer Planets Science Working Group), which from 1991 to 1994 spelled out scientific priorities for possible Pluto missions. Flagstaff people who served on the OPSWG included Buie and Lowell astronomer Ted Bowell. In 1993, a scientific conference was held in Flagstaff, leading to a 728-page

book on Pluto and Charon published as part of the University of Arizona Press's Space Science series. This volume, edited by Alan Stern and David Tholin, distilled what had been learned about Pluto and Charon from decades of telescopic observations, including stellar occultations and the recent mutual events.

Further scientific impetus came with the discovery of additional trans-Neptunian objects, starting in 1992. From being seen as an isolated oddball, Pluto soon became one of the largest, brightest and most interesting members of the Kuiper belt, a whole new zone of the solar system, ripe for exploration. Younger generations of planetary scientists were especially energetic proponents of Pluto and Kuiper belt exploration. Many had been inspired to enter the field by Voyager 2's initial reconnaissance of Uranus and Neptune, seeing Pluto as the last chance to participate in the scientifically revolutionary excitement of such an initial exploration. Only the first spacecraft to visit a previously unexplored world could deliver that. Being young, they had every expectation of living long enough to see a mission reach its destination, and in the meantime, they propelled the science forward by exploiting continuing technological advances in astronomical instrumentation.

Grundy and Buie organized a scientific workshop at Lowell Observatory in September 1999 about Triton and Pluto. The workshop happened to coincide with a time when teams were being formed to propose scientific instruments to be flown on the next iteration of a possible NASA Pluto mission, this one called Pluto Kuiper Express. Over lunch in the Slipher Building Rotunda, clusters of scientists huddled around the tables to hatch plans, speaking in whispers so as not to be overheard by their potential competitors having similar whispered conversations at other tables. But as anyone who has visited the Rotunda knows, the room's acoustics are tricky, with echoes being focused into unexpected places by the domed ceiling. One could easily overhear fragments of whispered planning conversations among other groups but not easily see who was speaking.

Grundy, along with Lowell Observatory's John Spencer, joined Stern's team, proposing an instrument package for Pluto Kuiper Express called PERSI (Pluto Express Remote Sensing Investigation) in early 2000. But instead of selecting instruments, NASA abruptly canceled the Pluto Kuiper Express project. It was quickly replaced with a new call for proposals, this time for an entire Pluto–Kuiper belt mission rather than just scientific instruments to be flown aboard a NASA spacecraft. Stern's PERSI team joined with the Johns Hopkins University's Applied Physics Laboratory and

Outer Planets Science Working Group (OPSWG) meeting in April 1991, chaired by Alan Stern. *Dale Cruikshank.*

Some of the attendees of the 1993 Pluto meeting in Flagstaff, including Marc Buie. *Dale Cruikshank.*

other partners to propose New Horizons in response to that call in early 2001, one of five proposals submitted. Two of the five were approved for further study, and of the two, New Horizons was selected for flight. But it began life under a cloud, with the White House's 2002 budget zeroing out its funding.

The culmination of the campaign to build scientific support came just in time to save New Horizons when the National Academy of Sciences, Congress's scientific research organization, weighed in with its recommendation for planetary exploration priorities during the decade 2003–13. The report placed a Pluto and Kuiper belt mission as its very top-priority, mid-sized mission, providing crucial support for the final push to fund construction of the New Horizons spacecraft and to get it to the launch pad in time. Many Flagstaff people contributed input to the academy's report, including a series of community white papers organized by Mark Sykes of the Planetary Science Institute in Tucson. Grundy led the community white paper on exploration goals for the Kuiper belt and Pluto, raising many scientific points that ultimately found their way into the academy's report.

The American public was interested and supportive, too. The public mood toward Pluto exploration was captured in a 1991 series of postage stamps celebrating NASA's history of solar system exploration. The last stamp in the series showed a featureless disk and the provocative title "Pluto Not Yet Explored." Public engagement played a key role in getting the mission launched. Supporters reacted to each of the many cancellations and setbacks by flooding Congress and NASA with more and more letters. Many of them were spontaneous, and others were orchestrated through campaigns led by organizations like the Planetary Society. One influential Internet campaign was run by a Pennsylvania high school student, Ted Nichols. The public wanted to get on with exploring the solar system and see what surprises Pluto held, and Congress responded favorably to their interest.

New Horizons was finally launched from Kennedy Space Center on January 19, 2006, aboard an Atlas 5 rocket, with five strap-on solid rocket boosters. This powerful rocket configuration gave the small and light New Horizons probe the fastest Earth departure of any spacecraft launched.

Despite that speed, the team would still have to wait nine years and six months before they would see Pluto up close. Time and effort equates to money, and budget realities required the team not to spend much time on the project during the intervening years. Work had been intense during the construction phase, and would be so again with the Pluto encounter, but had to be held to a minimum during the long cruise, a funding profile described as "the bathtub." Stern recognized that completely stopping work for such a long time risked losing key people and knowledge, so he arranged a series of activities to keep the team engaged at a low level

during that period, beginning with planning a complex series of scientific observations associated with the Jupiter gravity assist in early 2007. That proved to be a key shake-down for the team, as they learned how to work together to operate the spacecraft and its suite of instruments. Following publication of results from the Jupiter flyby in a special issue of *Science Magazine* in the fall of 2007, the team worked to design in detail every observation and maneuver to be done during the Pluto encounter, while the lessons learned from Jupiter were still fresh. When the Pluto encounter sequence was completed, the team turned to other activities, including searching for potential post-Pluto Kuiper belt targets and for potential hazards in the Pluto system such as debris rings. They planned alternate sequences that could have been triggered shortly before arrival at Pluto, in case anything threatening was found. No such hazards were spotted, but Pluto's tiny fourth and fifth satellites, Styx and Kerberos, were discovered as a result of those observations.

Additional activities included working to refine Pluto's 248-year orbit around the Sun. Considering that Pluto was only discovered in 1930 and the earliest pre-discovery photographic plates to have serendipitously captured it were from 1914, Pluto would not yet have completed even half of an orbit around the Sun by the time New Horizons arrived. This led to substantial uncertainty about its exact location, a problem for a spacecraft zipping past at thirty thousand miles per hour and attempting to snap pictures. The team tried various ways to improve knowledge of Pluto's orbit, including digitizing and measuring all of the Pluto plates taken by Carl Lampland during the decades between Pluto's discovery and Lampland's death in 1951. Buie led that effort, working with Brian Skiff at Lowell to clean all the glass plates and package them up for safe shipping.

Carl Lampland was involved in several aspects of Pluto work at Lowell Observatory, from the early searches to post-discovery studies. *Lowell Observatory.*

During the years leading up to the encounter, the New Horizons team organized a series of scientific workshops to boost engagement with the broader

scientific community. These included a 2011 meeting hosted at Lowell Observatory on the geology and geophysics of Pluto and related bodies. Increasing scientific interest in Pluto culminated in an early 2015 *Icarus* special issue containing thirty-four papers on Pluto system science and predictions.

Rather than being organized around individual instruments, as many NASA science teams are, the New Horizons science team was organized around four scientific themes: atmospheres; geology, geophysics and imaging; surface compositions; and particles and plasmas. These were abbreviated ATM, GGI, COMP and P&P. Each science theme team was able to draw on data from any of the instruments as needed. Multiple theme teams were interested in data from each of New Horizons' instruments, so this structure worked well to minimize contention for resources such as storage on the spacecraft's data recorders and time to make observations during the encounter. Grundy headed the COMP theme team.

The pace of science team activities gradually ramped up during the last two years before the encounter. The theme teams began to hold regular telecons to divide roles and tasks and to plan out and create the software tools and libraries of background data that would be needed during the encounter. They also planned a strawman sequence of scientific papers that would need to be written and who would lead each of them.

A variety of Operational Readiness Tests (ORTs) during the last two years were especially intense. These were multi-day rehearsals simulating the work that would happen during the encounter period. The team did ORTs to practice the end-to-end process of handling brand-new Pluto data, working with fake data that had been prepared in secret by a separate group. The steps involved processing it, trying to work out what it meant and developing a coherent scientific story including text, quotes and graphics that could be communicated to the public, all under realistic time pressure. The team learned many valuable lessons from these ORTs, including how to divide up tasks and work efficiently as a team. They revealed the need for further software tools (often different from what had been anticipated) that the team had to create.

Another valuable lesson was that scientists are terrible at writing press release–style prose. Their instinct is to lay out all of the evidence first and build step by step from the data to the conclusion. Reporters and press releases start with the headline or "lede" and then expand into the details. In the end, the team decided to hire experienced science writers to help them craft the stories to be communicated to the public. David Aguilar

led a team of science communicators, with one embedded in each theme team. They would be in the room as the scientists developed new ideas and made discoveries and would craft press releases in consultation with the science theme teams.

By the time of the encounter, the team was thoroughly sick and tired of planning efforts and rehearsals but was unusually well prepared for what was to come.

PLUTO EXPLORED!

Beep.
—New Horizons spacecraft

New Horizons had been built at and was commanded from the Johns Hopkins University's Applied Physics Laboratory (APL) in suburban Columbia, Maryland, so that was where the New Horizons team converged for the spacecraft's encounter with Pluto in 2015. Team members began arriving in late May and early June, well over a month ahead of the July 14 flyby. The principal investigator (PI), Alan Stern, wanted each science theme team to be on the ground and running smoothly before the world began to take notice.

In 2014, construction had begun on a new hotel adjacent to the APL campus. This would be an ideal place for the science team to stay, so a large room block was negotiated. Unfortunately, little by little, the planned completion date kept getting pushed back. By spring 2015, it had become clear that the new hotel would not be ready in time. New arrangements had to be made, and the team dispersed to hotels across central Maryland, with everyone commuting to APL.

Another plan that had to be abandoned was for all four science theme teams to work side by side in E100, a single large room in Building 200 at APL. One of many lessons learned from the ORTs was that it was too noisy and distracting to work in such an environment. In the end, E100 was only used for plenary meetings. Each of the theme teams was assigned a large,

windowless room of its own. COMP team was the exception. It had several foreign nationals for whom badging was more complicated, so for a while it was thought that they could remain in the plenary room, located in a part of the building that did not require an APL badge. But that was a lousy work environment, and ultimately, COMP team got its own room, too. All that was available by then was a spectacular executive meeting room with glass walls on three sides overlooking the lobby and the lawn to the south. The COMP team happily took up residence there.

SUMMER IN MARYLAND

The science team members quickly settled into a routine, living out of their hotel rooms and working long hours at APL, organized around a daily cycle of meetings. There was a morning science team plenary meeting; individual theme team meetings; meetings involving instrument and spacecraft operations teams; meetings with the embedded science writers and NASA and APL Public Affairs Office (PAO) people; and meetings between theme team leads, PI and project scientists. This pattern of activity spooled up well before there was much in the way of new discoveries about Pluto to talk about.

Summer in Maryland is hot and muggy, punctuated by occasional thunderstorms. For people working indoors in windowless rooms, it was easy to lose track of the real world outside, so the COMP team drew visitors from the other theme teams who were starved for daylight. Each of the theme team rooms was kept well stocked with coffee, tea and snacks. Stuart Robbins, who did much of the shopping, was on the GGI team, so its snack selection was the most comprehensive, again encouraging visitation between the teams. People took breaks from work to toss a Frisbee outdoors or to pull pranks on one another.

When appearing in public on behalf of the mission, everyone was encouraged to wear the team uniform: a black polo shirt with the New Horizons logo. Such public appearances ramped up as the flyby approached. Most people had at least one spare mission shirt, but it still required thinking strategically about which day's mission shirts would be needed and when there might be an opportunity to run a quick laundry load.

NASA, APL and the New Horizons project team itself were all intensely focused on public communication, with everyone wanting to carefully

manage the message. So the process of developing press and image releases involved many layers of review, all of which had to be done quickly in order to get the word out as fast as possible, hence the daily cycle of PAO meetings. Although everything was supposed to be carefully vetted before release, the process was not perfectly watertight. A photo of team members reacting to new images in the PAO meeting room accidentally included cellphone numbers of many of the embedded science writers written on a whiteboard in the background, leading to their receiving some very odd phone calls. Even within the federal government itself, coordinating communication could be surprisingly clumsy. The White House, in the midst of finalizing a historic nuclear accord with Iran, was dismayed to see NASA and New Horizons eclipsing news coverage of the Iran deal. Reportedly, they even asked NASA to shift the time of the Pluto encounter to a more convenient date, not realizing the trajectory had been set in place years before and could no longer be changed.

Everyone relied on the "playbook," which described details of each data set, including when it would be taken and, most importantly, when it would be transmitted to Earth. As soon as something new arrived on the ground, day or night, the relevant teams would immediately process it and report on new discoveries. At first, the pace was relatively leisurely. Of all the scientific instruments, only the LOng Range Reconnaissance Imager (LORRI) had the spatial resolution to resolve Pluto months before the flyby. LORRI consisted of a one megapixel black-and-white camera mounted on an eight-inch telescope.

The navigation and hazard assessment teams were among the first to have real work to do. During May and June, they received a steady stream of LORRI images. These were transmitted back to Earth almost as soon as they were taken so that the navigation team could assess whether course corrections were needed to ensure New Horizons passed through the system on track and on time for the encounter sequence to work as designed.

The tremendous speed of the spacecraft (about thirty thousand miles per hour) meant that colliding with even a sesame seed–sized particle could be catastrophic, so the hazard team was on the lookout for rings, debris clouds or new satellites. Any such thing might hint at the presence of debris along the planned trajectory through the system. John Spencer, formerly of Lowell Observatory, led the hazard team, and two other former Lowell staff were also on it: Buie and Simon Porter. Special LORRI deep-imaging campaigns were being done to search for potential hazards that might argue for switching to an alternate, backup trajectory. The team called

these alternatives SHBOT (Safe Haven By Other Trajectory). Some of the alternate encounter plans involved orienting the spacecraft's antenna toward the direction of motion during the flyby to use the sturdy seven-foot dish as a shield. But that would also mean turning the cameras away from Pluto and its satellites, with terrible consequences for science. Many on the broader team were worried that even without evidence for any hazard, a risk-averse NASA leadership might demand the safer, backup trajectory. Everyone agreed that flying a SHBOT was preferable to losing the spacecraft, but nobody wanted to do it unless it was demonstrably necessary. The pressure was thus on the hazard team to quantitatively assess the probabilities and make recommendations to NASA and the New Horizons team. It was a great relief when the final decision was made to stick with the original encounter sequence that had been so carefully honed during the cruise years.

Although they were taken primarily for navigation and hazard assessment purposes, the LORRI images were of great interest to the rest of the science team, too. Pluto and Charon were easily separated in them. Even from as early as a few months out, they showed more detail than Hubble images from previous decades had, and day after day, the resolution kept getting incrementally better. The team could increasingly make out recognizable features rotating into and out of view as Pluto spun about its axis. Press releases of these images could only apply descriptive names like "brass knuckles," "whale" and "doughnut," since the resolution was still too low for geological interpretation.

Tod Lauer, an astrophysicist at the National Optical Astronomy Observatories (NOAO) in Tucson, was an expert in image processing and deconvolution. His experience dated back to the early days of Hubble and its aberrated primary mirror. As a member of the hazard team, he applied those same algorithms to the LORRI images to sharpen them as much as possible. This processing revealed additional subtle features that were initially impossible to make out in the raw images but were evidently real, as shown by later images.

One of the enigmatic features in those early, deconvolved LORRI images was a dark area around Charon's north pole. There was a lot of speculation on the science team as to what it might be: an impact basin? Some sort of lava flow? Late one evening, Grundy was talking about it with Randy Gladstone, head of the ATM theme team. Gladstone had been thinking about the fact that the pole had been in continuous sunlight for the past few decades and so was possibly the warmest place on Charon's surface (perhaps as warm as 60 K or -350° F). Could that seasonal warmth cause sublimation

loss of a bright coating to reveal a dark substrate? Or could something be thermally processed into a darker material? Neither scientist could think of any plausible candidate material that made sense, and Charon's surface was known from spectroscopy to be dominated by water ice, which is inert at such low temperatures. The "ah-hah!" moment came when Grundy realized that Charon's poles experience comparably extreme cold temperatures during the long, dark winter season. If it ever got cold enough to freeze out the thin wisps of gas escaping from Pluto's atmosphere and streaming past Charon, that winter volatile ice reservoir could be processed by energetic space radiation into dark, reddish molecules called tholins. The next morning, they outlined this idea at the science plenary meeting and predicted that if this process was indeed responsible, the dark spot should be made of tholins. But it would be a while before that was confirmed.

The color camera on New Horizons (Multispectral Visible Imaging Camera, or MVIC) had a spatial resolution of about a factor of three coarser than LORRI, so MVIC was not being used for the regular hazard and navigation imaging. But the embedded science writers and PAO people were frustrated that the LORRI images were black-and-white and clamored for color images to share with the public. An early series of MVIC color images covering one Pluto rotation showed Pluto and Charon as point sources, much too low resolution to even tell if Charon's polar cap was reddish. However, the MVIC colors could be used to colorize the LORRI images, and this was done for multiple generations of progressively higher-resolution LORRI images. But as the LORRI images continued to improve and no new MVIC images were transmitted to Earth, the mismatch in resolution between the two became more and more extreme, and the science team's willingness to paint the LORRI images with the unresolved color diminished. A new set of higher-resolution color images had been scheduled to come down July 6, with a resolution of about 150 miles per pixel. That would have been sufficient to resolve Charon's pole, as well as many of Pluto's features.

JULY 2015

But it was not to be. On July 4, just ten days before the Pluto closest approach, New Horizons entered an emergency safe mode. Heroic efforts on the part of the mission operations team quickly worked out what had gone wrong and recovered the spacecraft within a few days. It turned out that

the onboard computer had been overloaded as a result of new commands being uplinked at the same time that the computer was compressing images. Of course, the same sequence of commands had been rehearsed on the spacecraft simulator at APL, with no failure. But the images on the simulator were blank, which made them a lot easier to compress than the real images that New Horizons was capturing. Apart from a good scare for NASA and the team, and the loss of those color images, little real harm resulted. The spacecraft was back to normal operations in time for one full Pluto rotation up through closest approach, meaning that better images than the ones that had been lost were obtained for all longitudes.

A daily cycle of press releases showed off increasingly detailed LORRI images, though still black-and-white. The next set of color images was not scheduled to come down until the "failsafe" dataset the day before closest approach. Each day, the embedded writers and PAO people worked with the theme teams to describe what they were seeing, but there are only so many ways to express "the New Horizons science team is thrilled by the latest images of the Pluto system showing enigmatic features in even more detail."

In the last week before closest approach, the public and media began to focus much more intensely on the upcoming encounter. Hundreds of reporters and VIP guests began arriving at APL. They were hosted at the Kossiakoff Center, across the street from Building 200. Of course, they all wanted to talk to science team members, but the mechanism to schedule interviews was clumsy, one of the few things the team had not actually rehearsed during the ORTs. So enterprising reporters ferreted out contact info for science team members and contacted them directly. Smaller media outlets, such as those based in Flagstaff, were having trouble getting through because the overwhelmed PAO staff were unable to keep up with the demand. They were triaging requests by only setting up interviews for the largest media outlets. Kevin Schindler, Lowell Observatory's public information officer at the time, had also traveled to APL for the encounter and was able to work around the clogged official process to set up interviews for Flagstaff media organizations. His method involved spotting a science team member just as another interview was ending and running over to buttonhole them while simultaneously dialing one of the frustrated Flagstaff reporters on his cellphone.

On July 13, the "failsafe" data set was transmitted to Earth. This transmission was an insurance policy, guaranteeing that at least some valuable scientific data would be returned even if the spacecraft was lost during closest approach. It provided the team with spectacular images to

Lowell staff past and present who served on the New Horizons team gather with observatory sole trustee W. Lowell Putnam for a radio interview during the Pluto flyby event. *From left to right*: Putnam, Simon Porter, Will Grundy, John Spencer, Marc Buie and Cathy Olkin. *Kevin Schindler*.

The New Horizons science team excitedly taking in their first up-close glimpse of Pluto at 7:00 a.m. the morning of July 14. *NASA/JHUAPL/SwRI/H. Throop*.

release during the encounter day, when the spacecraft was too busy recording new data to spend time transmitting anything home.

One of the "failsafe" observations was an MVIC color scan of Pluto and Charon, finally well resolved, which confirmed that Charon's pole was indeed red. By the time those images arrived, the PAO team's demands for color had reached such a crescendo that COMP team responded by exaggerating the color. This made a somewhat surreal image, but it revealed the complexity of Pluto's regional color variations. To avoid giving the impression that Pluto would actually look so colorful to the human eye, this was quickly followed by a natural color version of the same image.

The highest-resolution "failsafe" LORRI image of Pluto was scheduled to be received just after 11:00 p.m. on July 13. NASA and the PAO team wanted to film the entire science team reacting to it, but Stern did not want to require everyone to stay up late the night before closest approach. He wanted the team well rested in preparation for all the public attention anticipated for the fourteenth. So a deal was negotiated in which every team member had to promise not to look at the image when it came in and instead show up at 7:00 a.m. the next morning for the big reveal. A handful of science team members, including Simon Porter, were deputized to work overnight to process the image and have it ready to view in the morning.

Will Grundy is projected onto the big screen during the Pluto flyby event in July 2015 at the Applied Physics Laboratory in Maryland. *Kevin Schindler.*

Celebrating the success of New Horizons are, *left to right*, associate administrator for the Science Mission Directorate at NASA John Grunsfeld, principal investigator Alan Stern, mission operations manager Alice Bowman and project manager Glen Fountain. *Kevin Schindler.*

The day of the closest approach, July 14, started off with the team assembling in the E100 plenary room for their first look at the new LORRI image. Naturally, the image was greeted with excited discussion as everyone rushed up to the large screen for a closer look, pointing out the many curious features, and giving the photographers all the footage they could wish for of excited scientists in action. The rest of the day was a blur of interviews—far too many to count—a press briefing and a series of events for media and VIP guests involving cake cutting, flag waving, speeches and cheering. Of course, for people used to the careful planning of spaceflight, all of this had been planned out in advance, even down to having a backup pair of the "Pluto Not Yet Explored" stamp images that appeared in a number of photos. The climax was probably the buildup to the moment when the first post-flyby signal, a simple beep, was received from New Horizons. When the beep came, it confirmed that the spacecraft was still alive, that it had performed the encounter sequence as planned and that its solid state data recorders were filled with new science data. While there was hardly any doubt on the part of the team that the encounter would go according to plan, the theatricality of the phone home event still resonated.

NEW YORK TIMES DATASET

The first data set to be transmitted back after closest approach was colloquially referred to as the *New York Times* dataset. It contained a few choice observations from each of New Horizons' scientific instruments, highly compressed in order to get them down as quickly as possible. The compression produced strange-looking jpeg artifacts, but the data enabled the science team to release a spectacular series of images and new discoveries over the days following the encounter, culminating in another press conference on July 17. Images from the NYT dataset lived up to the ambition of their nickname, appearing above the fold on the front page of the *New York Times* on July 16.

A highlight of the week for the COMP team was seeing their infrared Pluto spectra displayed on the Jumbotron(TM) in New York's Times Square on July 18. The standard wisdom is that scientists should never even attempt to show spectra to the public—only images, never "wiggly lines." The fact that New Horizons' wiggly lines from Pluto were shown on the Jumbotron signified that the public was, at least for the moment, incredibly engaged in outer solar system exploration.

After the encounter phase, the science team dispersed and the pace relaxed, but only a little. The calendar was dictated by the slow communication rate from the edge of the solar system. Owing to the low power of the spacecraft's radio transmission (24 watts maximum) and small size of its antenna (seven feet), the highest possible data rate was only about 2,000 bits (2 kbit) per second. This is extremely slow, as anyone old enough to remember connecting to the Internet over a telephone line using a modem will recall. Typical modem speeds were much higher at 24, 36 or 56 kbit/sec. At this rate, which Lowell astronomer Gerard van Belle characterized as a "tweet per second," it took about a year and a half for New Horizons to transmit all of the encounter data home, though of course the science team prioritized the order so that the most important observations were sent first.

There was plenty of work to be done as the encounter data trickled in. For an entire year, the team put out weekly image and news releases. The process to develop these communications was modeled on the daily cycle of meetings during the encounter phase but now conducted via telecons instead of in person and spread over the course of a week, instead of repeating every day. The team was also busy writing scientific papers, including five that appeared in a special issue of *Science* in late

2016 and dozens more that came out in a special issue of *Icarus* in early 2017. There were also presentations to create and present at a series of scientific meetings, colloquium talks whenever anyone visited another institution, plus countless public talks. Considerable data processing work was needed, too, since all of the data had to be delivered to the public Planetary Data System (PDS) archive, along with higher-level products such as maps and image mosaics. Many of the papers and data products had delivery deadlines, meaning that the quality of the work had to be tailored to the available time rather than doing the best that can be done and taking as long as that requires, a very different mode from how individual scientists usually operate. Thus, the early papers were quickly superseded by subsequent ones, and those were, in turn, eclipsed by later papers.

Whenever an especially exciting image arrived, the science team would pore over it and exchange a surge of e-mail, pointing out interesting features. A good example was the MVIC panchromatic image looking back at a crescent Pluto, showing numerous haze layers, as well as incredibly diverse geology across the surface. For a while, the team referred to this as the "wow image," since "wow!" was everyone's initial reaction to it. At one point, several news stories emerged, quoting from the team's internal e-mail discussion of this image, causing consternation about how that material could have been obtained. Eventually, a server misconfiguration was identified as the source of the leak. An archive of the ATM team's e-mail traffic had been accidentally posted on the Internet and was indexed by search engines, enabling it to be found through web searches.

Overall, the New Horizons Pluto encounter was a spectacular success, despite a few glitches. The last time that a previously unexplored planet had received its first up-close visit was the Voyager 2 encounter with Neptune in 1989. This was even more novel, since Pluto was the first of its class of small icy planets to be explored. Through New Horizons, a new generation across the globe experienced the thrill of this kind of discovery for the first time. And it wasn't just a reprise of the Voyager-era exploration. Public communications has advanced by leaps and bounds since 1989, with the Internet and social media now playing key roles. Spacecraft instruments and data processing tools have advanced tremendously, as well. Where the Voyager team had submitted their initial "ninety-day reports" for publication three months after a flyby, the New Horizons team submitted their first such manuscript to *Science* only three weeks after the flyby, with the final published version appearing in print at the ninety-day mark.

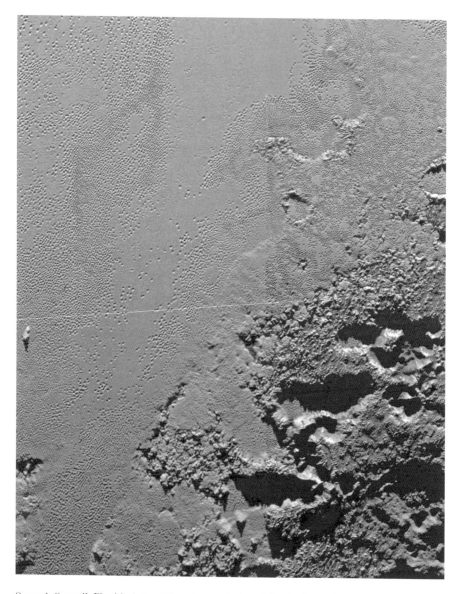

Smooth Sputnik Planitia (*upper left*) and rugged Krun Macula (*lower right*). *NASA/JHUAPL/ SwRI.*

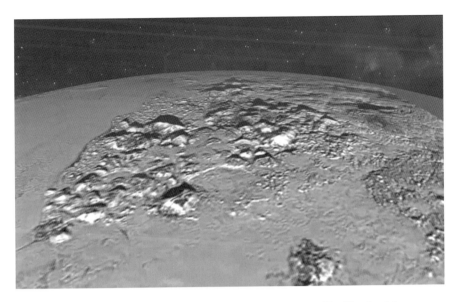

Synthetic re-projected view of smooth Sputnik Planitia interrupted by Tenzing Montes. *NASA/JHUAPL/SwRI.*

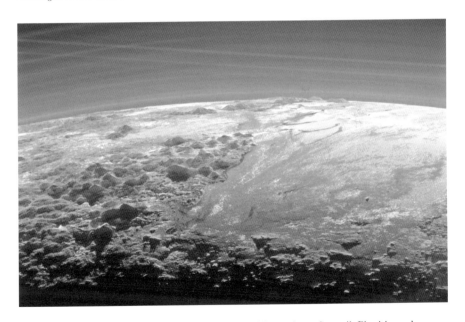

A small part of the "wow!" image showing layers of haze above Sputnik Planitia and rugged mountains to the west of Sputnik. *NASA/JHUAPL/SwRI.*

And where the public followed along with Voyager via newspapers and broadcast television news, by 2015, everyone could get the latest results from Pluto in their pocket on their smart phone.

According to all metrics tracked by NASA, public engagement reached record highs, raising the bar for future missions. Much of the credit can be given to Pluto itself. For decades, it had been the tiny, oddball, unexplored runt of the solar system. Many people had a special fondness for it, especially after the IAU's 2006 attempt to redefine the word "planet" so as to exclude Pluto and its cousins in the Kuiper belt. Of course, the New Horizons team's hard work was crucial, too, as was the leadership of the PI, Alan Stern.

HOME OF PLUTO

Pluto was discovered just 85 years ago by a farmer's son from Kansas, inspired by
a visionary from Boston, using a telescope in Flagstaff, Arizona. Today, science
takes a great leap observing the Pluto system up close and flying into a new
frontier that will help us better understand the origins of the solar system.
—*John Grunsfeld*

While Columbia, Maryland, served as the focal point of scientific and media activities on New Horizons flyby day, Flagstaff, Arizona, also enjoyed time in the limelight. The reason traces back to Pluto's strong ties to not only Lowell Observatory, as evidenced throughout this book, but the Flagstaff community at large.

On a large scale, Flagstaff is like other cities across America, where attitudes about Pluto are typically positive and even a bit personal. It was discovered in this country, so people possess a national pride in "our planet." Then there's the notion that everyone loves an underdog—"poor little Pluto," "everyone picks on Pluto" and the like. And we can't forget its association with a certain lovable cartoon puppy of the same name.

Yet Flagstaff has a passion for Pluto that far exceeds that of most other communities. A closer look at this northern Arizona city's legacy of scientific research, as well as residents' support of those efforts, reveals why this community embraces Pluto as much as, if not more than, any other place in the world.

PLUTOTOWN, USA

The area around Flagstaff features an incredible breadth and diversity of natural resources. The largest Ponderosa pine forest in the world stretches across the landscape. One of Earth's most extensive chasms, the Grand Canyon, lies just to the north, while the best-preserved crater caused by the impact of an object from space perforates the table-flat land to the east. Billions of years of Earth history are on display in the layers of rock crisscrossing the terrain, and the dark skies above make for an ideal locale from which to study the heavens.

For centuries, people have observed and recorded these natural phenomena in northern Arizona. At an archaeological remain known as Crack-in-Rock, located within modern-day Wupatki National Monument, the orientation of a wall with three windows suggests ancients may have used it to observe and mark the motions of the Sun. When nonnatives began coming to the area several hundred years later, they recognized the scientific resources on display. By the late 1800s, expeditions came to the area specifically to collect scientific data. Clinton Hart Merriam, for instance, studied the succession of climate zones and corresponding life, ranging from the depths of the Grand Canyon and deserts to the east of Flagstaff to the top of the nearby San Francisco Peaks. He used this information to introduce his now-classic life zone scheme.

In 1894, Percival Lowell established the area's first permanent scientific establishment, the astronomical observatory that bears his name and is at the center of so much of this Pluto story. Since then, numerous other observatories, museums and institutions dedicated to scientific research have appeared. The result: Flagstaff is not only the site from which Pluto was discovered but also boasts the country's first forest experimental station, served as a training ground for the astronauts who set foot on the Moon from the late 1960s to early 1970s, was named in 2001 as the world's first International Dark Sky City and is the country's first designated STEM city, in recognition of the community's efforts to promote science, technology, engineering and mathematics.

This scientific research has grown with the community of Flagstaff. In days of old, scientists rubbed shoulders with cattle drivers and lumbermen. Influence of the latter two lessened with time, and other industries such as education and tourism came to bear. But science has remained as a defining component of the community, part of the very fabric of Flagstaff and one in which locals take pride: not only is science carried out here,

but it is openly celebrated. Residents have long come out to hear their scientists speak and explore for themselves the very skies, rocks and plants that are under study.

This appreciation for science in Flagstaff culminated in 1990 with the formation of the Flagstaff Festival of Science, originally a three-day event (later expanded to ten days). Its mission is to "connect and inspire the citizens of northern Arizona, particularly youth, with the wonders of science and the joy of scientific discovery." As New Horizons flew by Pluto in 2015, the festival was going stronger than ever, the longest-running free science festival in the country and a testament to the community's ongoing support of science.

With this obvious dedication to and love for science, it's not surprising that Flagstaff residents and scientists alike take great pride in the planet discovered in their own backyard. Flagstaffians love their science, love their astronomy and love their Pluto. Not surprisingly, the location of much of the Pluto research in Flagstaff—Lowell Observatory—celebrates Clyde Tombaugh and his planet in a number of ways. A bust of Tombaugh sits along the Pluto Walk—a scale model of the solar system that begins near the building where Tombaugh maintained an office and ends in front of the dome housing the Pluto discovery telescope. A number of exhibits highlight Lowell's involvement with Pluto, from Tombaugh's discovery of it in 1930 as a dot on a glass plate to the New Horizons' revelations about its nature as a dynamic world. The glass plates, log books, notebooks and relevant correspondence are all here, as is the apartment where Tombaugh lived when he made the discovery, as well as his office and the room in which the blink comparator discovery machine was housed. Then there is the discovery telescope itself, which remains one of the most popular attractions to visit at Lowell and which underwent an extensive renovation in 2017. Other remaining facilities involved in the observatory's search for Planet X include the dome of the forty-two-inch reflector and foundations of the five-inch and nine-inch telescopes.

For years, the blink comparator machine stood on display at Lowell, and guests could peer through the eyepiece and discover Pluto for themselves, just as Tombaugh did on that cold day in 1930. It then went on display at the Smithsonian's Air & Space Museum in Washington, D.C., the same facility that houses such iconic items as the Wright Flyer, Lindbergh's *Spirit of St. Louis* and Chuck Yeager's X-1 plane that he used to break the sound barrier. With its return to Lowell in 2019, it will remain on permanent display at the observatory where Tombaugh made his fantastic discovery.

Alden and Annette Tombaugh by the bust of their father, Clyde, along Lowell Observatory's Pluto Walk. *Kevin Schindler.*

Lowell Observatory also maintains a Pluto-related donation box, on display since Pluto's reclassification in 2006. Prior to that time, the observatory maintained a Plexiglas box in which visitors could drop money in order to support general operations. With the reclassifications, staff created a new donation receptacle, with four smaller boxes. A sign declared, "What should Pluto be called: vote with your wallet." Guests could then make their preference be known by dropping money into one of the four labeled boxes: "Planet," "Dwarf Planet," "Other," "I don't care! I just want to support Lowell." Donations tripled over the ensuing year, with the majority of "votes" going for "Planet."

Lowell's gift shop offers a variety of Pluto-related items, from posters and cups to T-shirts with clever messages such as "Pluto Demands a Recount," "When I Was Your Age Pluto Was a Planet" and "Lowell Observatory: Home of Pluto."

Of course, while Lowell has been the center of the Pluto story in Flagstaff, it is not the only place where Pluto-related research happens here. The United States Naval Observatory's Flagstaff Station and Northern Arizona University (including a state-of-the-art ice lab) have also played important roles.

Beyond Lowell and these other research facilities, Flagstaff's support for Pluto has been palpable and unique. On the west side of the city is

Left: Donation box at Lowell Observatory that allows guests to "vote" on what Pluto should be called. *Kevin Schindler*.

Below: Matt Bovyn, Steve Tegler and Will Grundy build an apparatus to study cryogenic ices at Northern Arizona University in Flagstaff. *Steve Tegler*.

SIGNATURE ROLLS

THE KARMA*
Tempura shrimp, cream cheese & tobiko topped with freshwater eel, avocado, sweet sauce, wasabi cream & spice • 12.95

FIRECRACKER*
Tempura shrimp, krab, cucumber, avocado topped with spicy scallop & krab mix, tempura crunch & eel sauce • 12.95

COBB* ⓖ
Fresh tuna, snow crab & crispy bacon topped with avocado & jalapeño aioli • 12.50

DIAMONDBACK
Tempura shrimp, krab & cucumber. Topped with boiled shrimp, avocado, scallion & Thai chili ponzu • 12.95

HAWAIIAN*
Tuna, cream cheese, avocado, jalapeño, tempura-fried krab stick topped with fresh pineapple, lemon, Thai chili ponzu & sesame • 12.95

LOX N' BAGEL ⓖ
Vidalia onion, cream cheese, cilantro, capers & avocado. Topped with smoked salmon, wasabi aioli & nori crunch • 10.95

INARI ⓥ
Sweet Inari tofu, cucumber, roasted red pepper & avocado. Rolled in sesame paper & topped with sweet sauce • 8.50

BUDDHA*

PLUTO*
Tempura lobster, snow crab, cream cheese, cucumber & tobiko topped with avocado, sweet potato purée, sriracha, & spicy honey ponzu • 12.95

On Tuesday, February 18, 1930, the day Clyde Tombaugh discovered the planet Pluto at Flagstaff's Lowell Observatory, he ate lunch in this building, where the Black Cat Café operated for over 40 years, from Prohibition through the 1960s!

BLACK CAT
Tempura asparagus, spicy lobster

Above, left: Sign for Tombaugh Way, on the west side of Flagstaff. *Kevin Schindler*.

Above, right: Flagstaff glass blower George Averbeck holds one of his Pluto ornaments. *Kevin Schindler*.

Left: Menu from Flagstaff's Karma Sushi Restaurant, with a description of the Pluto Roll. *Kevin Schindler*.

In 2015, the Flagstaff coffee house Late for the Train offered Pluto Blend Coffee. *Sarah Gilbert.*

Tombaugh Way, a pedestrian reminder of Clyde and his Pluto legacy. During 2015—Pluto flyby year—Karma Sushi Restaurant in downtown Flagstaff featured a sushi roll known as the Pluto Roll that was stuffed with tempura lobster, snow crab, cream cheese and cucumber and topped with a medley of sumptuous sauces and spices. Just two blocks away was an art gallery featuring blown glass ornaments of Pluto created by local ceramic artist George Averbeck. A nearby coffeehouse, Late for the Train, produced a specialty "Pluto Roast" blend. Another artist, Paula Rice, created two different figurative ceramic sculptures representing Pluto. The first is part of her nine-piece Planet Series displayed in the lobby of Northern Arizona University's Ardrey Auditorium. She made this one well before New Horizons unveiled the true nature's of Pluto's surface. She later created a new Pluto sculpture based on our new view of the planet.

All this adds up to a strong community appreciation for its adopted planet. Here in PlutoTown, USA, scientists and artists, lay public and merchants stand shoulder to shoulder in celebration of that tiny planetary body that calls Flagstaff home. This community of Plutophiles was thus pretty charged up when New Horizons brought Pluto to the forefront of world news in mid-2015.

JULY 2015

On July 14, 2015—Pluto flyby day—Lowell Observatory hosted an all-day celebration of Pluto. More than six hundred guests swarmed Mars Hill to participate in tours, listen to astronomers and educators lecture about all things Pluto and even get Pluto-themed tattoos. Meanwhile, a smaller group of guests gathered for a private celebration at the trustee's residence.

Television monitors at both the public and private events were set to NASA TV, which carried live coverage from the New Horizons mission control center at the APL in Maryland. Thus, the Flagstaff-based observers, as well as millions of other Plutophiles around the world, could follow some of the frenetic activities happening there. And those observers could be pardoned if they mistook the APL proceedings for some sort of Lowell event, as Lowell Observatory people—past, present and future— were prominently featured.

As discussed in the last chapter, at front and center was current Lowell planetary scientist Will Grundy, the leader of the New Horizons surface composition team. He was joined by Percival Lowell's great-grandnephew (sole trustee Lowell Putnam) and great-great-grandniece (Flynn Vickowski), as well as Clyde Tombaugh's two children, Annette

Will Grundy is surrounded by reporters from around the world as he answers questions during the New Horizons flyby event. *Kevin Schindler*.

The New Horizons flyby event welcomed VIPs from around the country. Here, Streator, Illinois natives Siobhan Elias (*far left*) and her husband, Kevin (*far right*), join Cherylee and Alden Tombaugh (*second and third from left*) and their grandchildren. *Kevin Schindler.*

At the New Horizons flyby event, Jim Christy (*center*) participated in a discussion about Pluto's moons. *Kevin Schindler.*

and Alden, and their families, who had traveled from New Mexico to take part in the festivities. New Horizons scientists with Lowell ties seemed everywhere and included former observatory astronomers John Spencer, Cathy Olkin and Marc Buie, along with Simon Porter and Amanda Zangari—all now working at the Southwest Research Institute in Boulder. Lowell researchers Stephen Levine and Amanda Bosh, both of whom have studied Pluto (though neither was on the New Horizons team), were also on hand. Kevin Schindler rounded out the Lowell team, coordinating remote interviews with Flagstaff media and providing content for the observatory's social media outlets. Jim and Charlene Christy also represented Flagstaff, joining in many of the festivities. These participants were joined by other scientists, worldwide media and luminaries, such as science personality Bill Nye the Science Guy, NASA administrator Charlie Bolden and popular science writer Dava Sobel.

By evening, both the Flagstaff observers and APL crowds were bursting with anticipation for New Horizons' "phone home," the beep that would signify the spacecraft's successful pass by Pluto. The moment came at 8:52:37 p.m. EDT (5:52:37 Flagstaff time). Simultaneously, guests in Lowell's Giclas Lecture Hall erupted in cheers and tears, the VIPs at the trustee's house clanged celebratory glasses of champagne, guests at

Lowell's Brian Skiff and Alma Ruiz-Velasco sit on the floor and watch the July 14, 2015 New Horizons coverage with guests at Lowell Observatory. *Jake Bacon.*

APL cheered and waved American flags and the scientists hugged and high-fived.

While these festivities played out, Grundy tried calling his wife, Bonnie, who was attending the Lowell VIP event. She didn't hear her cellphone ring because of the revelry but finally noticed that he had called. Looking for a quiet place to return his call, she went into the nearby Pluto dome, where Clyde Tombaugh discovered Pluto long ago. This added a surreal element to an already dreamlike experience.

The world was soon marveling at the spectacular images sent back by New Horizons. But the defining moment of the mission came with that simple beep. This signified humanity's successful completion of a glorious voyage of discovery, in the same way that the beep's visual counterpart, that dot that Clyde Tombaugh detected back in 1930, culminated a grand search for knowledge and paved the way for the beep eighty-five years later.

The exploration of Pluto is of worldwide interest, but Flagstaff has a special fascination, almost an ownership, in these efforts because of this community's long, curious association with that distant icy body. Flagstaff and Lowell Observatory in particular are rightly called the "Home of Pluto."

IS PLUTO A PLANET?

There seems to be no doubt that the term planet to the best of our knowledge best fits the object. Of course, if Leuschner likes he might call it a giant minor planet, but it will go right on being just what it is in spite of all we think or say about it or the names we call it.
—V.M. Slipher

On August 24, 2006, the Twenty-Sixth General Assembly of the International Astronomical Union (IAU) voted to reclassify Pluto from its long-standing designation of "planet" to a newly coined designation of "dwarf planet." Almost immediately, requests for comments began lighting up the lines at Lowell Observatory. Every major news organization around the world called us to get our take on the historic "demotion" of the little world discovered at Lowell in 1930, a near-continuous drumbeat of phone conversations that lasted two full days. The questions were clearly phrased to elicit our emotional response: "How outraged are you?" and "How will you fight back?" Similar sentiments poured into our e-mail inboxes: "How could they do this to poor Pluto?"

THE HORROR! THE HORROR!

Looking back in 2017, the IAU decision has been very good for Lowell Observatory. It sparked renewed public interest in Pluto and, by extension,

the outer solar system, which over the last twenty-five years has emerged as a fascinating new frontier in astronomy. It came only months after the launch of New Horizons, whose nine-year journey across the solar system gradually ramped interest in Pluto to a fever pitch as it approached its 2015 flyby. Attendance to our outreach programs soared in 2015 from 80,000 to nearly 100,000 visitors per year, a rise that turned out to be not a spike but a plateau. Lowell and its hometown of Flagstaff are the "Home of Pluto," and all other issues aside, we hold up that banner proudly.

In the aftermath of the IAU vote, however, the reclassification created a dilemma for Lowell. The media and incensed members of the public were clearly looking for a loud denouncement, but to do so would have flown in the face of all Lowell stands for as an institution of science. We practice our trade as fairly and faithfully as we can. This means objective and dispassionate analysis of evidence, development of logical and defensible conclusions and rigorous communication of those results, both in the full technical sense for professional audiences and in accessible but equally accurate ways for lay audiences. It also means that if a long-held idea—for example, that there are nine planets in the solar system—can be satisfactorily shown to be incorrect, we must always be prepared to change our minds. (Too often in the public eye, scientists are considered at best wishy-washy or at worst incompetent if they change their minds, when, in fact, changing one's mind, if and when data require that one do so, is the very essence of science.) Especially as the discoverers of Pluto, when any negative pronouncement from us would have been magnified in the hysteria and could only have been viewed as emotional Pluto-machismo, our wading into the fray was inappropriate.

In talking with all those reporters in 2006, therefore, we took a nuanced position. We pointed out that beyond all the brickbats being tossed at what you call Pluto, a little spaceship was on its way there as we spoke, and it would no doubt revolutionize our ideas about what Pluto was really like. We also noted that Will Grundy was a key part of that mission team, so Pluto science was still alive and well at Lowell. If Pluto was actually a planet, then everyone's favorite mnemonic was, thank heaven, intact; if it wasn't a planet but, in fact, was the archetype of a new class of object in the solar system, then the discoverers at Lowell Observatory had led that charge by sixty-two years. We felt—and still feel—that the clues to our origins in the outer solar system holds, the wondrous and deeply surprising vistas of Pluto and Charon returned by New Horizons and the insights we've received into physical processes under extreme conditions all take precedence over what you call something.

But do we not care at all what you call Pluto? Not exactly, though we care for reasons other than wanting to walk around flexing in Pluto T-shirts. To put the term "planet" in a scientific context, we first must have a look at what the IAU has decided a planet is and how that definition came about.

A VIEW TO A PLANET

Here is the current definition of "planet" as adopted by the IAU.

✧ First, in the solar system, *a planet orbits the Sun*. That excludes an object like Ganymede, not only the largest moon of Jupiter but also larger than Mercury. (In a sense, of course, Ganymede *does* orbit the Sun.) Pluto fits this criterion, sort of—it orbits the Sun in a pairs-skater-like wobble with its relatively massive moon Charon.

✧ Second, a planet is, colloquially speaking, *big enough to be a ball*. More technically, its mass and self-gravity create a condition called hydrostatic equilibrium, pulling it into a near-round shape. Pluto fits that criterion, too.

✧ Finally, a planet (again colloquially) is *big enough to be a bully*, meaning it has kicked all the celestial detritus out of its orbit. Pluto, living as it does in the busy swirl of objects in the Kuiper belt, fails this criterion.

In contrast, the new idea of a "dwarf planet" describes an object that strictly meets the first two criteria above (meaning that it is mostly round and, like Ganymede, not a satellite of something else) but fails the third. Somewhat confusingly, it was decided that a "dwarf planet" is not a "planet," despite the appearance of that word in its name. These new definitions of *planet* and *dwarf planet* were adopted on the last day of the 2006 IAU meeting, and as they say, therein hangs a tale.

THE STORY OF THE PLUTO VOTE

The year 2006 was an exciting and pivotal one in planetary science. The beginning of the year saw the launch of the New Horizons spacecraft to

the final unexplored planet in our solar system, Pluto. New Horizons was a tiny spacecraft that was perched atop the largest rocket available at the time in the United States inventory, and when the United Launch Alliance Atlas V 551 was lit up, it shot off the pad like it was unglued. The Atlas V normally launches payloads twenty times larger than New Horizons, so it's no surprise that the spacecraft was the fastest thing ever off the pad—New Horizons crossed our Moon's orbit in only nine hours (a task that took Apollo astronauts three days). The saga of the development and ultimate launch of the New Horizons mission is an epic odyssey in and of itself; suffice it to say, it is reasonable to note that the planetary status of Pluto played a significant role in the political decision to fund the New Horizons mission.

The earth-shaking launch of New Horizons was being matched by other tectonic shifts in planetary science. In the years immediately preceding 2006, a number of large outer solar system bodies had been discovered by the trio of Mike Brown, Chad Trujillo and David Rabinowitz, including Makemake, Orcus and Quaoar. However, it was the announcement of the discovery of the distant body Sedna in 2004 that finally prompted the International Astronomical Union to set up a nineteen-member panel to give guidance for creating the definition of the term "planet," led by astronomer Iwan Williams. The IAU is the international body that, among other things, adjudicates naming conventions of objects in the sky; since planets—up until then—had been discovered only infrequently, there was no formal IAU machinery in place for arriving at naming of planets. This is in contrast to the IAU's well-established and well-exercised norms for naming asteroids and features on planetary surfaces. The motivation for the "planet" debate took on further steam with the July 2005 announcement of a body the Brown-Trujillo-Rabinowitz team playfully code-named Xena (which ultimately was given the formal name of Eris); initial estimates that Xena was larger than Pluto stoked the fires of the debate.

The year 2006 also had the virtue—or calamity—of being a year in which the IAU was holding its triennial General Assembly (GA), in August in Prague. The GA is a two-week-long meeting in which old friends and colleagues renew acquaintances, much science is discussed and—unique to the GA—agreements are made regarding standards and norms of information exchange within astronomy. Some of these debates are esoteric and removed, centering on matters such as definitions of distance scales or agreeing to annual leap seconds; other debates are occasionally of great interest, such as the meaning of the word "planet." At times, these debates

are then presented to the attendees of the GA for resolution at the conclusion of the two weeks, for firm decision by means of voting.

A nineteen-member committee tasked with recommending a definition of "planet" had given way to a smaller body, led by astronomer and historian Owen Gingerich, and including five planetary scientists and science writer Dava Sobel. This slimmer body had generated a specific proposal for consideration by the astronomers attending the GA. And what a proposal it was! It had two elements of the definition noted above: a planet orbits a star, and it is in hydrostatic equilibrium (our "big enough to be a ball" condition). This would have had a few immediate consequences. First, the largest asteroid in the solar system, Ceres, would have gained planetary status. More precisely, Ceres would actually *regain* planetary status, for when it was discovered in 1801, it was considered a planet for the following forty years. Second, Charon, the moon of Pluto, would have been elevated to planet status, and the Pluto-Charon system would be considered a binary planet. This is because the two objects are sufficiently equal in mass that they actually orbit a point located partway between the two (the barycenter).

It is interesting to note that the Earth-Moon system *almost* qualified as a binary planet as well under this definition. The barycenter of the Earth-Moon system is still interior to the Earth—and hence the Moon is strictly speaking definitely a subsidiary satellite of Earth—but the barycenter is actually much closer to the surface of Earth than the center of Earth. Additionally, in the next few billion years, with the evolution of the Earth-Moon orbit due to tidal forces that will expand the size of the Earth-Moon separation, that barycenter will ultimately shift to be exterior to the Earth. As such, the Moon would then become its own planet—under those rules.

Finally, in a nod to the straw that broke the camel's back in this regard, the body Xena would indeed be recognized as a planet as well. Not lost on those GA attendees reading this original proposal was the fact that many of the newly discovered outer solar system bodies would probably also attain planetary status under these rules and that many more—up to two hundred—were probably on the cusp of being discovered with the new advances in technology that had already revealed Xena, Sedna, Orcus and their ilk.

At the IAU meeting, this caused quite a stir. In the previous months, rumors had already been swirling in the astronomy community of something big afoot, and this initial proposed definition did not disappoint in its ability to add a dramatic element to the meeting. Some reactions were aghast—"What is this business with binary planets?" and "How could we live with so many

planets?" (The idea that we mustn't have "too many" planets is particularly absurd. Memorizing lists of facts and object names is utterly useless, and no student should ever be forced to waste his or her time doing it. Much more relevant is, for example, teaching them the beautiful laws that govern how the universe's myriad planets, whose names are trivially accessible online, move under the influence of gravity.)

Other reactions were a bit more measured. "We've never defined the word 'star' or 'galaxy,' and everything is fine. Why start now?" and "We have plenty of binary stars, what's the big deal?" It made for a never-ending store of dinner-time conversation among the attendees at the 2006 Prague IAU GA; the debate was, to say the least, vigorous. Over the course of the two weeks of the GA, revisions of the definition were iterated upon, accreting over time the dynamical aspects ("big enough to be a bully") noted above.

All of these paths led up to the final day of the meeting, which traditionally for IAU GAs is when resolutions are presented to the assembled membership for voting. The attendance at that point in the GA, which had swelled to as many as two thousand during the preceding two weeks, had shrunk to only about four hundred members. Members were a little worn out after such a long meeting—almost all other meetings in astronomy run three to five days—and many had left prior to the final day. Included in the resolutions were nail-biters such as "Precession Theory and Definition of the Ecliptic," "Supplement to the IAU 2000 Resolutions on Reference Systems," "Endorsement of the Washington Charter for Communicating Astronomy with the Public" and—more importantly for this discussion—Resolutions 5A, "Definition of 'Planet,'" and 6A, "Definition of Pluto-class Objects." Passage of Resolutions 1 through 4 received the usual perfunctory rubber stamp from the general membership that the IAU Executive Committee, which was running the meeting, had come to expect: the individual members recognized they were no experts in the proposed resolutions, and these members were inclined to defer to the opinions of the expert committees contained within those resolutions.

The planet resolutions were a little different. Lowell astronomer Gerard van Belle—at the time an employee of Caltech—was one of those four hundred astronomers present at the vote and recounts his experience:

Arriving at the consideration of Resolution 5A, all hell broke loose. People had opinions! And they were willing to put them squarely in the way of the experts, who clearly had hoped to serve up their proposal to the

Gerard van Belle (*center*) holds his Pluto voting card at the 2006 General Assembly of the International Astronomical Union. *Gerard van Belle.*

general membership for another cursory rubber stamp. Debate from the floor was energetic, ribald and poorly managed by a shell-shocked Executive. A painful need for a well-versed parliamentarian manifested itself and went unmet. This was seen in the final outcome: debate was ultimately cut off, and a vote on Resolution 5A went uncounted—the IAU release documenting the event simply notes the contentious issued "passed with a great majority." Modified resolutions, such as 5B, were introduced from the floor, and further trampling on basic parliamentary procedure was seen, as amendments to these ensuing resolutions were introduced in the middle of voting. I've seen better organized train wrecks, but unfortunately, we have to live with the result of Resolution 5A passing, which is simply tragic—it's universally derided, and not a single astronomer I know abides by the letter of the law it dictates. It remains a landmark to this day on why we don't typically do science by vote—especially a rushed, badly managed vote.

Dr. van Belle voted against Resolution 5A.

WHAT'S IN A NAME?

The helter-skelter described here hardly aligns with what we consider science, which is the realm of the demonstrable, the steady analysis of evidence to arrive at a logical and solid conclusion. Like the basic proofs of mathematics, the language of science, a rigorously constructed scientific argument, is beautiful to read. Yet as the what-you-call-Pluto issue clearly reveals, science is also an intensely human process. On one hand, rigorous as we may be, intuition and good judgment are undeniable components of scientific investigation. On the other, topics that should be purely scientific can become highly entwined with emotion or religion (think evolution) or politics (climate change).

The classification of Pluto as a dwarf planet certainly falls in the emotional bucket; the oft-used word "demotion" is a poster child for this tendency, connoting relegating to has-been or second-class status. And the adoption of a definition by vote sends a message that a fundamentally political process drives science: whatever the majority thinks is what has to be the case. Against this rather charged background, let's consider what classification means from a more scientific standpoint.

First, let us put aside the sometimes-cited position that what you call Pluto is irrelevant. It *is* relevant. Classification is a legitimate and valuable scientific pursuit. For example, for over a century, astronomers have conducted exhaustive analyses of the spectra of stars, leading to a classification system of spectral types and luminosity classes with both coarse and detailed components. Assignment of a spectral type immediately communicates, in a succinct set of letters and numerals, an immense amount of information about the basic properties of a star. Any *individual* star will then have idiosyncrasies that need examination in greater detail, but the spectral type provides a powerful starting point for understanding what's going on in a self-gravitating ball of plasma hundreds of trillions of miles away. Analogously, the great system of biological classification that traces back to Linnaeus provides a powerful view into the organization of life on Earth and the basic ways in which various manifestations of that life go about their existences. One could even argue that if science itself asks a single, fundamental question, that question might be, "How is the universe organized?" Classification is an element of understanding that organization.

Second, we must remember that classification is fluid. Current-day field guides to the insects, for example, contain a different set of orders within class *Insecta* than appeared in the volumes of the 1970s. Given the dizzying

number of insect species, as well as the fine details of structure that often distinguish them, it is hardly surprising that insect taxa are regularly being rearranged. Moving a species of moth from one family to another family is hardly a demotion (or a promotion); it simply reflects the better understanding of nature that more and better-quality data have provided. We should, therefore, not be at all surprised that as we became aware of a fascinating swarm of objects in the deep outer solar system, the question of how to classify an object like Pluto came up. It has even happened multiple times before: as noted above, the dwarf planet Ceres used to be an asteroid and before that was considered a planet.

Finally, we must always construct classification schemes to reflect nature as simply as possible and in a way that incorporates that broadest set of observed phenomena. Awkward or forced constructs, or schemes with too many "rogues" that don't fit, usually indicate a problem with the scheme, not the objects. With these tenets as a foundation, it becomes clear that revisiting the classification of Pluto was quite appropriate. The last twenty-five years have seen an extraordinary revolution in our awareness of small objects orbiting stars, both close to home in the form of the Kuiper belt and around stars everywhere we look with ground-based exoplanet-detection instruments and with spacecraft like NASA's Kepler mission. Planets, or things that look like planets, are everywhere. How many are there? We don't know, but whatever the number is, it's not nine. What is it really, and how do we best define a "planet"?

PLUTO IS A...

In our opinion, the adopted IAU definition fails in two critical ways.

✧ First, it is location-based. It specifically addresses objects in the solar system, despite the thousands of analogous objects we are discovering around other stars. To return to our insect analogy, it is as if a species of moth is defined only to be so if it is found in Flagstaff; if an identical specimen turns up in Phoenix or Tucson, it must be something different.

✧ Second, it adopts the awkward and contrived notion of "clearing an orbit," a property fiendishly difficult to confirm even for objects in our own solar system, let alone around other stars. A

classification system that stymies efforts to use it to classify objects is not overly helpful. And the mile-wide Barringer meteor crater just thirty-five miles from Flagstaff leads one to wonder if, under the requirement of a "cleared orbit," Earth itself can be called a planet. In fact, if we were to teleport Earth out to the distance of Pluto, it suddenly would not be a planet. After whatever period of time it then took to gravitationally kick all its newly nearby Kuiper belt objects into other orbits, it would become a planet again. This is a bizarre and unhelpful classification criterion.

Far more reasonable was the original definition presented to the IAU, which retains the "big enough to be a ball" criterion and goes on to require only that a planet orbits a star but is not itself a star (meaning it does not generate its own energy via thermonuclear fusion) and is not a satellite of a planet (which again would disqualify large moons like Ganymede). Even with this definition, fine points and gray areas still exist, but it is a much simpler and more scientific proposition that rests only on basic physical properties of the object, rather than location or vagaries of dynamical evolution. Under this criterion, Pluto is a planet, as are quite a number of other objects in the solar system—several of the largest known Kuiper belt objects such as Sedna and Eris, along with asteroids Vesta and Pallas in addition to Ceres. (Because of the low mass ratio of Pluto and Charon, one, in fact, could consider them to constitute a double planet.)

None of the considerations above, however, change the fact that relative to the rocky planets of the solar system (Mercury, Venus, Earth and Mars) and the giants (Jupiter, Saturn, Uranus and Neptune), Pluto is a decided oddball. Its orbit is inclined and elliptical. Its surface and interior structure appear entirely different from those of the other eight planets. It is considerably smaller even than Mercury and only modestly larger than Earth's Moon. It bears much more in common with its icy Kuiper belt compatriots than anything nearer to the Sun, and in that context, it is entirely fair to consider it a third class of planet; and given its small size, "dwarf planet" is a reasonable name.

So our conclusion is that yes, Virginia, Pluto is a dwarf planet. But under the best scientific definition of small objects orbiting stars, Pluto is also a planet, the prototype of a class unknown until recent years.

What will we call Pluto in the future? We don't know. We do know that our own solar system gives us only the tiniest glimpse of the planets of our galaxy, with an architecture not at all representative of many systems we see

around other stars. As we discover more about these distant worlds, many of which orbit stars very different from our Sun, we will no doubt have to rethink our understanding of the arrangements planetary systems can assume and redefine the most appropriate classification scheme to describe them. Perhaps the New Horizons flyby of Kuiper belt object MU69 will force a reexamination of how we classify our own solar system.

In any case, we see Pluto as one planet in a galaxy bursting with planets. Close to home, we know of rocky planets, gas giants, ice giants and dwarf planets. Farther afield, new terms have emerged: super-Earths, hot Jupiters, free floaters. Within the overall order of planets, we're finding more and more families, and their members are everywhere, certainly in the billions, perhaps the trillions.

The IAU resolution of 2006 was no more the end of the discussion than any of the debate since or this chapter itself. As we learn ever more, our terms and definitions will evolve; and as the complexity of what the universe presents to us steadily increases, we'll have the ongoing and fascinating challenge of defining the most sensible and scientific system we can find to describe it. We hope some of the young readers of this chapter will grow up to become astronomers and join the fun.

Oh, and that unassuming dwarf planet discovered on a cold night on a hill overlooking Flagstaff, Arizona? We're scientists, but yes, we love it. Always have, always will.

Jeffrey Hall
Lowell Observatory director

Gerard van Belle
Lowell Observatory astronomer

AFTERWORD

The story of Pluto's discovery and exploration told in this book is simply amazing. Just consider: a century ago, Percival Lowell had just died, and his will was still in probate. It took a decade for Lowell's chief lieutenant and successor as observatory director, Vesto Slipher, to resolve that legal contest, allowing Percival's estate to go forward per his wishes to fund a dedicated new telescope to look for his Planet X.

By early 1930, everything at Lowell Observatory had changed: the observatory had built that telescope, hired a young but talented and conscientious observer named Clyde Tombaugh to conduct the search, found Planet X, reported it to the world and named it Pluto.

In the decades that followed, with ever advancing technology, Pluto was studied by telescopes all around the globe and by several off our planet in Earth orbit as well. Pluto was found to be an exotic planet with much to teach us. But even more importantly, with the discovery of the Kuiper belt and Pluto's cohort of many sister planets there, beginning in the 1990s, Pluto was rocketed to the top of the NASA planetary exploration queue. By 2006, that mission of exploration, called New Horizons, which I led, was dispatched by NASA to traverse our solar system to its very frontier and explore Pluto and its moons. New Horizons reached Pluto in July 2015 and succeeded in all of its exploration objectives.

The images and other data that New Horizons beamed back to Earth astounded scientists and the public alike. Pluto turned out to be far more complex and far more geologically active than anyone had anticipated. And

in addition, the deep, viral interest the public showed in this exploration and discovery set new records for NASA and taught us something many had forgotten in the long years since Apollo and Voyager—people love the exploration of new worlds!

I am bedazzled that our species explores faraway worlds, and I'm not alone in that. We saw it in the way kids and adults alike were enchanted with the flyby of Pluto by New Horizons, the way the media was swept off its feet as well and even in the way that books like this one are being written to tell the tale.

Arizonans must feel a special pride, I imagine, for being the place where Lowell Observatory was able to make history and find not just planet Pluto but also, in Pluto, the harbinger of the Kuiper belt—our solar system's third zone and the first of the many new planets that orbit there—now known to be the most populous class of planet in our solar system.

None of this would have happened as it did were it not for Percival Lowell, Vesto Slipher and Clyde Tombaugh. Put another way, none of this would have happened without Lowell Observatory.

Pluto's complexity begs us now to return with a follow-up mission to orbit that amazing planet and study it in much greater detail. Pluto's complexity also begs us to explore the other planets of the Kuiper belt and to understand them as well as we do the terrestrial and giant planets, for they have much to teach us.

No one knows yet when the next mission to explore Pluto and other Kuiper belt locales will launch. But when it does, I am certain that the case for it will be built in no small measure by scientists now working at Lowell Observatory, and I suspect as well that, just like on New Horizons, scientists at Lowell will be among the teams that carry out that exploration.

S. Alan Stern
Principal Investigator of New Horizons Mission

TIMELINE FOR PLUTO AND FLAGSTAFF

1902
Percival Lowell gives a series of lectures at the Massachusetts Institute of Technology (MIT), during which he first announces his belief of the existence of a ninth planet.

1903
Lowell's MIT lectures are published in the book *The Solar System*.

1905
Percival Lowell begins the first of three search phases at his observatory for the theoretical ninth planet, which he calls "Planet X."

1905
Percival Lowell hires William Carrigan as the first of several computers to help with Planet X computations.

1905–6
John Duncan serves as Lowell Observatory's first Lawrence Fellow, a position designed to give research experience, particularly for the Planet X search.

1906
A farming family in Streator, Illinois, welcomes a new baby boy to the world. His name is Clyde Tombaugh, and he will one day head the third Planet X search that leads to the discovery of Pluto.

1906–7

E.C. Slipher serves as the second Lawrence Fellow.

1907

Kenneth Williams is the third—and last—Lawrence Fellow.

1908

William Pickering of Harvard College Observatory announces his own planet search and predicted positions for what he calls Planet O.

1910

Percival Lowell kicks off the second phase of his Planet X search.

1910

Elizabeth Williams takes over as head of Lowell's computer team.

October 11, 1911

Zeiss blink comparator machine arrives at Lowell Observatory.

April 14, 1914

Observatory staff first uses nine-inch Brashear telescope, borrowed from Swarthmore College's Sproul Observatory.

March 19 and April 7, 1915

Lowell Observatory observer Thomas Gill unknowingly captures images of Pluto on photographic plates.

1915

In what would turn out to be one of his last publications—*Memoir on a Trans-Neptunian Planet*—Percival Lowell estimates the location of Planet X based on mathematical calculations.

November 12, 1916

Percival Lowell dies and the second phase of the Planet X search ends.

1925

Guy Lowell purchases a trio of thirteen-inch glass discs. They will be used to build the telescope that Clyde Tombaugh uses to discover Pluto.

1929

Roger Lowell Putnam, sole trustee of Lowell Observatory, decides the observatory will recommence the search for Percival Lowell's Planet X. Percival's brother Abbott Lawrence Lowell, president of Harvard University, donates money to build a telescope specifically designed for the search.

January 2, 1929

V.M. Slipher offers Clyde Tombaugh a job at Lowell Observatory.

January 15, 1929

Clyde Tombaugh begins working at Lowell.

February 11, 1929

The three-element lens for the thirteen-inch search telescope arrives at Lowell Observatory.

February 16, 1929

Lowell staff take the first exposure with the new thirteen-inch search telescope.

April 6, 1929

Clyde Tombaugh officially kicks off the third phase of Lowell Observatory's Planet X search.

June 1, 1929

A five-inch Brashear camera, on loan from Wilbur Cogshall of Indiana University, is first used to capture backup images for the Planet X search.

January 21, 23 and 29, 1930

Clyde Tombaugh captures images of the sky where Lowell predicted the new planet would be located.

February 18, 1930

While examining the January 23 and 29 plates, Clyde Tombaugh discovers Pluto.

March 13, 1930

Lowell Observatory announces the discovery of Pluto, on what would have been Percival Lowell's seventy-fifth birthday.

May 1, 1930

Pluto is officially named, in a *Lowell Observatory Circular* written by V.M. Slipher.

June 22, 1978

Jim Christy of the U.S. Naval Observatory discovers Pluto's moon Charon on photographic plates taken at the Naval Observatory's Flagstaff-based sixty-one-inch telescope.

1985–90

Astronomers observe several mutual events involving Pluto and Charon.

1988

A team of scientists that includes Lowell astronomers detects Pluto's atmosphere.

1989

The "Pluto Underground" begins pushing for a mission to explore Pluto.

1991

The U.S. Postal Service releases a set of stamps celebrating planetary exploration. Pluto's stamp includes the title "Not Yet Explored."

1997

Will Grundy begins working at Lowell Observatory.

2001

NASA approves development of the New Horizons mission to Pluto.

June 15, 2005

A scientific team that includes then-Lowell astronomer Marc Buie and using the Hubble Space Telescope co-discovers two more moons orbiting Pluto, Nix and Hydra.

January 19, 2006

New Horizons launches from Cape Canaveral, starting a nine-year journey to Pluto.

2006
The International Astronomical Union votes to reclassify Pluto as a dwarf planet.

June 28, 2011
Pluto's fourth moon, Kerberos, is discovered from images taken with the Hubble Space Telescope.

June 26, 2012
A fifth moon, Styx, is discovered from images taken with the Hubble Space Telescope.

June 29, 2015
Lowell scientists join other astronomers around the world to observe a stellar occultation by Pluto, just two weeks before the New Horizons flyby.

July 14, 2015
New Horizons flies by the Pluto system, capturing the first-ever close-up images of Pluto and Charon.

BIBLIOGRAPHY

Books

Greenslet, Ferris. *The Lowells and Their Seven Worlds*. Boston: Houghton, Mifflin and Company, 1935.

Hoyt, William G. *Lowell and Mars*. Tucson: University of Arizona Press, 1976.

———. *Planets X and Pluto*. Tucson: University of Arizona Press, 1980.

Kepler, Johannes. Quoted in *The Watershed: A Biography of Johannes Kepler*, by Arthur Koestler. N.p., 1960.

Levy, David H. *Clyde Tombaugh: Discoverer of Planet Pluto*. Tucson: University of Arizona Press, 1991.

Lowell, Abbott L. *Biography of Percival Lowell*. New York: Macmillan Company, 1935.

Lowell, Percival. *The Evolution of Worlds*. New York: Macmillan Company, 1909.

———. "Great Discoveries and Their Reception." Unpublished lecture text, Lowell Observatory Archives, circa 1916.

———. *Mars and Its Canals*. New York: Macmillan Company, 1906.

———. *The Solar System*. Boston: Houghton, Mifflin and Company, 1903.

Putnam, William Lowell. *The Explorers of Mars Hill*. Flagstaff, AZ: Lowell Observatory, 1994.

Schindler, Kevin. *The Far End of the Journey: Lowell Observatory's 24″ Clark Telescope*. Flagstaff, AZ: Lowell Observatory, 2016.

———. *Images of America: Lowell Observatory*. Charleston, SC: Arcadia Publishing, 2016.

Schindler, Kevin, and Bonnie Stevens. *Flagstaff Festival of Science: The First 25 Years*. Flagstaff, AZ: Flagstaff Festival of Science, 2014.

Stern, S.A., and D.J. Tholen, eds. *Pluto and Charon*. Tucson: University of Arizona Press, 1997.

Tombaugh, Clyde W., and Patrick Moore. *Out of the Darkness: The Planet Pluto*. Harrisburg, PA: Stackpole Books, 1980.

Wister, Owen. *The Virginian*. New York: MacMillan Company, 1902.

Magazines, Correspondence and Other Sources

Arizona Daily Sun, February 17, 2005; December 28, 2013; August 30, 2014; February 14, 2015; February 28, 2015; June 6, 2015; June 20, 2015; July 18, 2015; August 29, 2015; May 21, 2016; June 11, 2016; October 8, 2016; January 14, 2017.

Bowman, Philip. Correspondence to Lowell Observatory, March 1930.

Buie, Marc. Personal communication, 2017.

Cohen, Ben. Correspondence to Lowell Observatory, March 1930.

Collier, E.K. Correspondence to Lowell Observatory, March 1930.

Dene, Monckton. Correspondence to Lowell Observatory, March 1930.

Dismukes, Gale. Correspondence to Lowell Observatory, March 1930.

Dunham, Theodore. Personal communication, 2017.

Flagstaff Business News, February 2015; August 2015; August 2016.

Giclas, Henry L. "A Brief of the Carl Lampland Diaries." Unpublished manuscript, Lowell Observatory Archives, 1982.

———. "Henry's Reminiscences of Lowell Observatory." Unpublished manuscript, Lowell Observatory Archives, n.d.

Grace, Delia. Correspondence to Lowell Observatory, March 1930.

Grunsfeld, John. Public speech at Applied Physics Laboratory, July 14, 2015.

Harbert, Josephine. Correspondence to Lowell Observatory, March 1930.

Harvard Observatory Announcement Card 108, March 13, 1930.

Horan, T. Correspondence to Lowell Observatory, March 1930.

Howie, Florence. Correspondence to Lowell Observatory, March 1930.

Lampland, Carl. Correspondence to Percival Lowell. Lowell Observatory Archives, September 25, 1912.

Leonard, Wrexie. Correspondence to Carl Lampland. Lowell Observatory Archives, March 22, 1911.

Lowell Observatory secretary. Correspondence to Monckton Dene. Lowell Observatory Archives, June 23, 1930.

Lowell, Percival. Correspondence to Carl Lampland. Lowell Observatory Archives, January 22, 1913; February 8, 1913; May 4, 1914.

———. "Memoir on a Trans-Neptunian Planet." *Memoirs of the Lowell Observatory* 1, no. 1 (1915).

Magoffin, Ralph. Correspondence to Lowell Observatory, March 1930.

Miller, John A. "The Sproul Observatory of Swarthmore College." *Popular Astronomy* 21, no. 5 (1913).

Millis, Robert. Personal communication, 2017.

Niehoff, Walter. Correspondence to Lowell Observatory, March 1930.

Nye, Ralph. Personal communication, 2017.

Putnam, Roger. Undated press statement. Lowell Observatory Archives.

Schindler, Kevin. "Before New Horizons, One Telescope Started It All." Astronomy.com, July 3, 2015.

———. "A Brief History of the 40-inch (42-inch) Clark Refractor." *Lowell Observer* 59 (2003).

———. "The Cosmic Announcement: Pluto Discovered from Lowell Observatory 75 Years Ago." *Mountain Living Magazine*, March 2005.

———. "Day of Discovery." Astronomy.com, February 1, 2005.

———. "Discovery Day: A Day to Remember." *Lowell Observer* 65 (2005).

———. "Down to Science: How Research and Discovery Shaped Flagstaff's Past." *Mountain Living Magazine*, Centennial Edition, 2012.

———. "Flagstaff: A Hub of Scientific Discovery." *Arizona Daily Sun* insert, 2014.

———. "How a Flying Telescope Proved Pluto Has an Atmosphere." Astronomy.com, June 3, 2015.

———. "Lowell Well Represented at Pluto Flyby Headquarters." *Lowell Observer* 105 (2015).

———. "Naming Pluto: Strange Suggestions for a 'Dark, Gloomy Planet.'" Astronomy.com, May 22, 2015.

———. "New Horizons Mission Leader Sharing Discoveries with Pluto's Hometown." *Arizona Daily Sun* insert, 2015.

———. "Percival Lowell: A Life in Astronomy." *Astronomy*, April 2017.

———. "Percival Lowell's Three Early Searches for Planet X." Astronomy.com, May 14, 2015.

———. "Pluto History: Newly Discovered Letter Offers Insight." *Mountain Living Magazine*, April 2003.

———. "Pluto Telescope Renovation." *@7000ft*, March 2017.

————. "PlutoTown, USA: Where Pluto Is, and Always Will Be, a Planet." Astronomy.com, June 25, 2017.

————. "Want to Discover Planet X? You'll Need These Three Tools." Astronomy.com, May 20, 2015.

————. "Young Clyde Tombaugh: How a Midwestern Farm Boy Set a Course for Pluto." Astronomy.com, May 18, 2015.

Schindler, Kevin, and Lauren Amundson. "How Pluto Got Its Name." *Astronomy*, March 2016.

Shapley, Harlow. Correspondence to Roger Lowell Putnam. Lowell Observatory Archives, April 5, 1930.

Skiff, Brian. Personal communication, 2017.

Slipher, Vesto M. Correspondence to Armin Leuschner. Lowell Observatory Archives, April 18, 1930.

————. Correspondence to Clyde Tombaugh. NMSU Archives, January 2, 1929.

————. Correspondence to Henry Norris Russell. Lowell Observatory Archives, May 12, 1928.

————. Correspondence to John Miller. Lowell Observatory Archives, April 19, 1930.

————. Correspondence to Roger Lowell Putnam. Lowell Observatory Archives, June 30, 1927; March 23, 1978.

————. "The Discovery of a Solar System Body Apparently Trans-Neptunian." *Lowell Observatory Observation Circular*, March 13, 1930.

————. *Lowell Observatory Observation Circular*, May 1, 1930.

Spencer, John. Personal communication, 2017.

Tombaugh, Adella. Correspondence to Clyde Tombaugh. NMSU Archives, March 16, 1930.

Tombaugh, Clyde. Correspondence to Adella Tombaugh. NMSU Archives, February 23, 1930.

————. Correspondence to Esther Tombaugh. NMSU Archives, March 9, 1930; March 24, 1930.

————. Correspondence to Muron Tombaugh. NMSU Archives, February 16, 1930.

————. Correspondence to William Graves Hoyt, recounted in Hoyt, 1930, *Planets X and Pluto*.

————. "Reminiscence on the Discovery of Pluto." *Sky and Telescope* 19, no. 5 (1960).

Tombaugh, Muron. Correspondence to Clyde Tombaugh. NMSU Archives, March 16, 1930.

Turner, H.H. Correspondence to Lowell Observatory. Lowell Observatory Archives, March 14, 1930.

Underhill, Karl. Correspondence to Lowell Observatory, March 1930.

Von Arx, William. Correspondence to Lowell Observatory, March 1930.

Wasserman, Larry. Personal communication, 2017.

Wolf, Florence. Correspondence to Lowell Observatory, March 1930.

Wynn, Walter. Correspondence to Lowell Observatory, March 1930.

INDEX

U

V

W

ABOUT THE AUTHORS

Kevin Schindler is a native of Ohio but has lived in Flagstaff for more than twenty years, working for most of that time at Lowell Observatory. He's always been interested in history, from the very old of the cosmos, to the less ancient of fossils, to the comparatively modern of scientists and their research. He graduated from Marietta College (in southeastern Ohio) in 1987, majoring in geology and with a strong focus on paleontology. He currently serves as Lowell Observatory's historian after two decades of leading the observatory's education and outreach efforts. Schindler is an active member of the Flagstaff history and science communities, having served as sheriff of the Flagstaff Corral of Westerners International for thirteen years and on the board of the Flagstaff Festival of Science for a similar length of time. When not digging through Lowell's archives, he writes articles for a variety of publications and contributes a biweekly astronomy column, "View from Mars Hill," for the *Arizona Daily Sun* newspaper. This is his fifth book.

Dr. Will Grundy is a planetary scientist who studies the physical characteristics, compositions and processes affecting icy planets, Kuiper belt objects and giant planet satellites. His research involves a variety of experimental techniques, including space- and ground-based imaging and spectroscopy and laboratory studies of cryogenic materials. He is an author on over one hundred scientific papers on these topics and is also an editor for *Icarus*, the leading international scientific journal for

solar system studies. Grundy heads the Surface Composition science theme team for NASA's New Horizons mission to Pluto and the Kuiper belt and is an instrument scientist on NASA's Lucy mission to explore Jupiter's Trojan asteroids. Grundy mostly grew up in Cleveland Heights, Ohio, but the family took occasional sabbatical years abroad, in Kampala (1967–68), The Hague (1972–73) and Galway (1979–80). His undergraduate degree was in physics from Yale University (1988) and his PhD in planetary sciences from the University of Arizona (1995). He did Chateaubriand and Hubble postdoctoral fellowships before joining the faculty at Lowell Observatory.

Visit us at
www.historypress.net